Happy Birthday, Melissa!

Be thinking of some places in here you might like to visit circa 1996!

I'd say Hassam really captures many of the moods of the city. Hope you like his work!

Love, Mikey

21 November 1995

NOTE ABOUT THIS SERIES

TO GET HOLD OF THE INVISIBLE, ONE MUST PENETRATE AS DEEPLY AS POSSIBLE INTO THE VISIBLE. THIS IS THE ESSENCE OF PAINTING. § THE ARTIST MUST FIND SOMETHING TO PAINT. PAVEL TCHELITCHEW SAID, "PROBLEMS OF SUBJECT-MATTER HAVE BEEN LIKE OBSESSIONS — IMAGES HAVE HAUNTED ME SOMETIMES FOR YEARS BEFORE I WAS AT LAST ABLE TO UNDERSTAND WHAT THEY REALLY MEANT TO ME OR COULD BE MADE TO MEAN TO OTHERS." THESE ESSENTIAL IMAGES AND THEMES IN A BODY OF WORK — PEOPLE, PLACES, THINGS — ARE EQUIVALENTS OF THE ARTIST'S INNER, INVISIBLE REALITY. § THE ARTBOOKS IN THIS SERIES EXPLORE SPECIFIC SUBJECTS THAT HAVE MOVED CERTAIN ARTISTS AND STIRRED OUR DEEPEST RESPONSES.

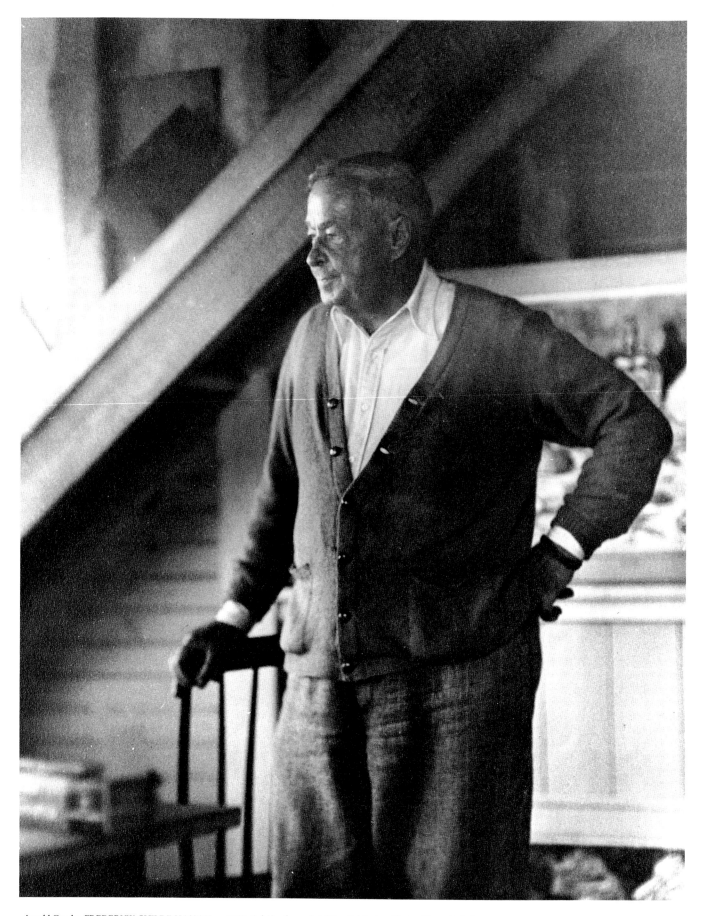

Arnold Genthe, FREDERICK CHILDE HASSAM, c. 1925, Gelatin silver print, 9¼ x 7⅛ inches, National Portrait Gallery, Smithsonian Institution / Art Resource, New York

A CHAMELEON BOOK

CHILDE HASSAM'S NEW YORK

Ilene Susan Fort

POMEGRANATE ARTBOOKS, SAN FRANCISCO, CALIFORNIA

A CHAMELEON BOOK

Complete © 1993 Chameleon Books, Inc.
Text © 1993 Ilene Susan Fort

Published by Pomegranate Artbooks
Box 6099, Rohnert Park, California 94927

Produced by Chameleon Books, Inc.
211 West 20th Street, New York, New York 10011

Creative director: Arnold Skolnick
Managing editor: Carl Sesar
Editorial assistant: Lynn Schumann
Composition: Larry Lorber, Ultracomp
Printer: Oceanic Graphic Printing, Hong Kong

Library of Congress Cataloging-in-Publication Data

Fort, Ilene Susan
 Childe Hassam's New York / Ilene Susan Fort.
 p. cm. — (The Essential paintings series)
 "A Chameleon book."
 Includes bibliographical references.
 ISBN 1-56640-317-0
 1. Hassam, Childe, 1859 – 1935 — Criticism and
interpretation. I. Title. II. Series.
ND237.H345F66 1993
759.13 — dc20 93-15920
 CIP

AUTHOR'S ACKNOWLEDGMENTS

While Hassam ranks as one of this nation's foremost Impressionists, his life and art have not been extensively investigated since his death. Historians have much fertile material to analyze, including the artist's unpublished papers, which are at the American Academy and Institute of Arts and Letters, New York. I would like to thank that institution, especially Nancy Johnson, archivist, for allowing me access to the material as well as for permitting me to quote from it.

No serious publication on Hassam can be accomplished without the assistance of the Childe Hassam catalogue raisonné project, which is being compiled by Stuart Feld and Kathleen Burnside of Hirschl and Adler, New York. As always, Kathy patiently answered my numerous inquiries. I want to thank the staffs of Christie's and Sotheby's for tracing the location of certain paintings, as well as the following galleries for bringing specific paintings to my attention: Berry-Hill Galleries, Graham Gallery, and Richard York Gallery, all of New York, and Keny Galleries, Columbus. Lee Scharf of the Discovery Museum, Bridgeport, was also helpful in the investigation.

Private collectors and public and academic institutions have generously permitted their fine Hassam works to be illustrated. Linda Muehlig, Smith College Museum of Art, Northampton, and Susan C. Faxon, Addison Gallery of American Art, Phillips Academy, Andover, provided me with unpublished information about the paintings in their respective collections.

At Chameleon Books I would like to thank Carl Sesar for his able editing and Lynn Schumann for methodically handling all the details involved in publishing a book. I am delighted that Arnold Skolnick conceived the idea of "The Essential Paintings" series, for it allowed me to return to investigating one of the masters of American art. And finally, thanks and a big hug to my husband, Gustavo Botvinikoff, for his patience and humor during the hectic days when I was cloistered away writing.

Ilene Susan Fort

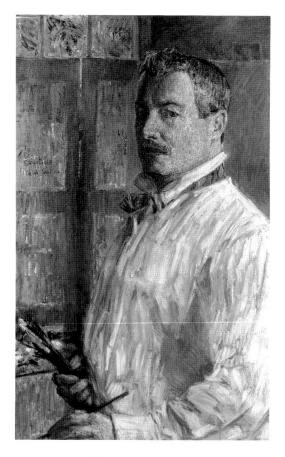

SELF-PORTRAIT, 1914
Oil on canvas, 32¾ x 20¾ inches
American Academy of Arts and Letters, New York

CHILDE HASSAM fell in love with New York after moving there in December 1889. Later he claimed it to be "the most beautiful city in the world."[1] By introducing an entire generation of Americans to the charm of ordinary city streets, he became the foremost delineator of the metropolis. His depictions were largely that of a romantic and Impressionist, but were not confined to the parameters of any single artistic movement. Above all, they were American in spirit. In Paris Hassam had learned a French aesthetic, but he was so overwhelmingly patriotic that he was able to transform it into his own national idiom. He captured both the picturesque spirit of genteel American society just before it gave way to a more democratic era and the raw energy of the modern, new metropolis that emerged in the early twentieth century.

The artist was born Frederick Childe Hassam on October 17, 1859, in Dorchester (now Boston), Massachusetts, and before his twentieth birthday had begun a career as a book illustrator. Turning to painting in the next decade, Hassam executed his first cityscapes during the years 1885 to 1887, exploring the streets of Boston in inclement weather. His style at the time was naturalistic, analogous to the academic painting of the *juste-milieu* (middle-of-the-road) artists of France.

After traveling to the French capital in 1887 for a two-year stay, Hassam became familiar with progressive trends. By the late 1880s, Claude Monet, Camille Pissarro, and other Impressionists were already famous for their sun-filled views of the French countryside and cities. Hassam would have felt a common bond with the Impressionists. Although he later insistently denied the direct influence of Impressionism, the movement did have an immediate impact on Hassam: his palette became lighter and in a higher key, his brushstrokes shorter and looser, and sunlight emerged as a frequent theme. By the end of the century Hassam would rank as one of the leading American Impressionists, and twenty years later, as its grand old master.

Hassam no doubt realized the wisdom of settling in New York rather than his hometown. The city was on the verge of achieving cosmopolitan status. It was wealthy enough to support a variety of artistic, literary and social groups, and soon after his arrival Hassam joined the Players Club and the Society of American Painters in Pastel. Through such circles he became friends with artists William Merritt Chase, Willard Metcalf, Joseph Pennell, and the grand old romantic Albert Pinkham Ryder; but even more important were the close ties he formed with Frederic Remington, John Twachtman, and J. Alden Weir. Together with Metcalf, Twachtman, and Weir, Hassam founded in 1898 the important secessionist organization, The Ten, which became influential in the promotion of Impressionism and Tonalism. Through his art, Hassam would contribute to the idea that New York was as sophisticated an international city as Paris, for he believed "the thoroughfares of the great French metropolis" were "not one whit more interesting than the streets of New York!"[2]

New York was the only locale Hassam depicted on a largely uninterrupted basis for over three decades.[3] His methodology was that of an Impressionist, for he set up his easel *en plein-air* (outside) in order to utilize natural light. However, Hassam did not always follow the French, who began the practice of completing an entire painting in one session. Instead, he sometimes brought his paintings back to the studio to be more fully developed. Hassam was reputed to be a rapid street sketcher. When he wanted to be on the level of pedestrians and near to them, he would sketch sitting in a cab, a practice that he might have learned from the *juste-milieu* painters Giuseppe

De Nittis or Jean Béraud.[4] At other times he would distance himself from the figures by working from a balcony or second-story window.[5]

By the end of the decade, Hassam was considered New York's "street painter par excellence."[6] The artist explained, "There is nothing so interesting to me as people. I am never tired of observing them in everyday life, as they hurry through the streets on business or saunter down the promenade on pleasure."[7] Street traffic, by foot or horse, was therefore the focus. According to writer Marianne Griswold Van Rensselaer, promenading along Fifth Avenue for the sake of mere enjoyment had been quite the fashion for decades.[8] The French Impressionists had initiated the depiction of contemporary urban life, recording the bourgeoisie at home and in the community. Hassam's world was more restricted. His focus on the facade of public life meant that he did not delve beyond what was happening on the pavements of New York: Hassam's pedestrians might glance into shops through the plate-glass windows, but they are rarely shown inside commercial establishments. Not until later did John Sloan, William Glackens, and other Ashcan painters depict New Yorkers in clothing stores, cabarets, and theaters, even going so far as to demonstrate a strong voyeuristic fascination with the intimate lives of the city's residents. Hassam remained within the boundaries of nineteenth-century etiquette, respecting propriety by keeping a distance and never probing beneath the surface.

Although Hassam roamed throughout Manhattan in search of subject matter, finding interesting views as far apart as Battery Park at the tip of the island and High Bridge in Washington Heights, his tendency was usually to paint or draw near his home. Hassam and his wife Maud initially took up residence in a studio at 95 Fifth Avenue, and his first painting to be purchased by a museum, *Fifth Avenue in Winter*, c. 1892, was of the intersection of Fifth Avenue and 17th Street as seen from this site.[9] The Hassams moved quite a few times in the next decade and a half until 1908, when they settled into the cooperative building at 130 West 57th Street. This apartment-studio would be their winter residence for the remaining years of Hassam's life.[10] Washington, Union, and Madison squares, and the side streets directly off of lower Fifth Avenue were his earliest subjects, while upper Fifth Avenue to Central Park, 57th Street, the upper West Side, and Central Park itself appear more frequently in his later depictions.

Hassam's movement reflected the growth of the city as a whole as it outgrew the confines of the lower region of the island and moved in the only direction possible, north, in search of open land to develop. The rich were usually the first to relocate: upper Fifth Avenue became "millionaire row" as department-store owner A. T. Stewart built a mansion at 34th Street in 1869 and, fifteen years later, William Vanderbilt had twin houses constructed for his family between 51st and 52nd streets. It was only a short time before the wealthier of the middle class moved, settling into houses and, by the early 1880s, into luxury apartment buildings near Central Park. Businesses soon followed.

In an 1893 *Century* magazine article illustrated by Hassam, Van Rensselaer noted the commercialization along lower Fifth Avenue that had transformed the tenor of the street.[11] During the 1890s, Hassam recorded what was to be the last phase of genteel tradition in this section of the city. Women wear stylish dresses and furs and men appear in top hats and suits. While he depicted the comfortable neighborhood around Washington Square Park, the once-fashionable area had already suffered some decline;

Jean Béraud
THE CHURCH OF SAINT-PHILIPPE-DU-ROULE, PARIS, n.d.
Oil on canvas, 23⅜ x 31⅞ inches
The Metropolitan Museum of Art
Gift of Mr. and Mrs. William B. Jaffe, 1955

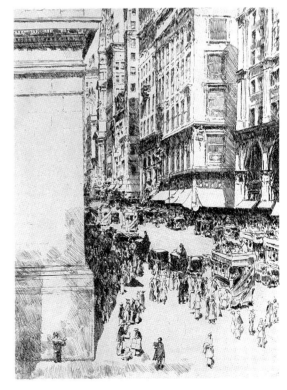

FIFTH AVENUE NOON, 1916
Etching, 9⅞ x 7½ inches
Private collection

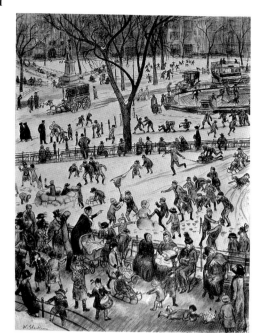

William Glackens, WASHINGTON SQUARE, 1913
Charcoal, pencil, colored pencil, gouache, and watercolor
29 x 22 inches
The Museum of Modern Art, New York
Gift of Abby Aldrich Rockefeller

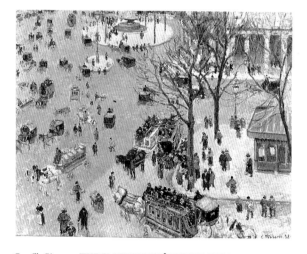

Camille Pissarro, THE PLACE DU THÉÂTRE FRANÇAIS, PARIS, 1898
Oil on canvas, 28½ x 36½ inches
Los Angeles County Museum of Art
Mr. and Mrs. George Gard de Sylva Collection

Van Rensselaer wrote of the "good people" who still lived there, but within two decades the quarter would be appreciated by a new crowd—artists and bohemians.[12] Madison Square Park, on the other hand, was at the peak of its popularity. The center of elegant hostelry, as recorded in *Spring Morning in the Heart of the City,* 1890, it boasted three luxury hotels as well as New York's first expensive cooperative apartment building, the Knickerbocker, and the famous restaurant Delmonico's. But Madison Square would soon suffer a fate similar to that of Washington Square, as indicated by Delmonico's move uptown to 54th Street in 1898.

Van Rensselaer, Richard Watson Gilder, editor of *The Century* and a friend of Hassam, and the artist himself all represented the refined sensibility and casual pace of upper-class society during the Gilded Age. By presenting New Yorkers in large scale, Hassam created city views that were actually genre scenes about this soon-to-be-lost lifestyle. Rarely, and only in the twentieth century, did he turn his attention to business, capturing the frenetic pace of the New York Stock Exchange.

French Impressionists first celebrated the subject of parks by depicting the bourgeoisie enjoying the public gardens of Paris that had proliferated after 1850 as urban planners incorporated nature into their renovation program. Americans, likewise, realized that urban dwellers needed a respite from the congestion and industrialization. Consequently, Frederick Law Olmsted and Calvert Vaux were hired in 1856 to design Central Park, the nation's earliest municipal park. The first American Impressionist to adopt the subject was Chase, who in 1886 began his series on Brooklyn's Prospect Park. While he and Hassam usually presented a few figures ambling quietly among flower beds and trees, the tranquility of the promenade ritual was soon to disappear. Maurice Prendergast's paintings and William Glackens's humorous *Washington Square,* 1913, reveal that city parks became not only congested and noisy, but also popular recreational facilities for people from all walks of life.

While the late nineteenth century witnessed the rise of enormous wealth, it was also a period of great social change and economic recession. Industrialization and massive waves of poor immigrants transformed the face of urban populations, and nowhere more drastically than in New York. Hassam's biographer, Adeline Adams, insisted that the artist loved New York just because "it held all sorts of people."[13] She went on to state that the artist liked to picture workers. Hassam did occasionally devote separate paintings to certain common-man types, such as a bricklayer and an old-bottle man, but his paintings were usually not about the lower classes. The inclusion of cabdrivers, street cleaners, and construction workers in his New York scenes merely reflected the supporting roles they played in the functioning of the city.

As Eliot Clark noted, Hassam did not "indulge in the sentimental aspect of squalor, or look with sympathetic gaze upon the picturesque life of the humble."[14] While Hassam's extolling of street life was innovative for late nineteenth-century American art, his attitude toward people remained elitist and conservative. He introduced the more prosaic aspects of urban living, but left it up to slightly later artists, namely the Ashcan circle, to explore the lower-class existence of foreigners. Hassam never focused on ethnic neighborhoods.[15] Critics of the period repeatedly praised Hassam and his art for their Puritan character.[16] What they meant was that Hassam devoted his paintings to his own middle-class, Anglo-Saxon culture.

Only sporadically throughout his long career did Hassam devote a painting, print, or drawing to working-class neighborhoods and industrial sections of the city, such as

5

the shipping docks along the North and East rivers. The choice of these subjects owed a debt to James A. M. Whistler's realistic London views of Chelsea and the Thames Embankment. Whistler's small oil studies of shop windows, begun in the early 1880s, probably inspired both the subject and treatment of Hassam's *The Messenger Boy,* 1903, and *Little Cobbler's Shop,* 1910. Years after painting them, Hassam spoke of his "little shop windows" in the context of Whistler's "small street things" he had admired in the collection of Charles Freer.[17]

Hassam's almost straightforward frontal perspective of the row of shops in these two paintings denies the existence of a large city beyond. By discarding his usual treatment of New York streets on a sharp diagonal or as part of a deep vista, Hassam equated these humble neighborhoods with small towns. Despite the placement of the Alwyn Auto School in the center of *Little Cobbler's Shop,* both shop scenes are about foot travel—as indicated by their titles and the inclusion of stores devoted to shoe repair—rather than motorized vehicles.[18] Hassam was rejecting the new dynamism and congestion of the city flooded with immigrants for a simpler, quiet place. His habit of summering in rural villages and isolated resort towns may have been his way of escaping from the increasing urban transformations, for it is thought that the landscapes he then painted represent a "backward looking sense of regret at the fast pace of modern life."[19]

This element of escapism might also explain why churches appear so often in Hassam's New York images, occasionally as the focus, but usually as one of many buildings in the urban environment, indicated by a partial steeple, tower, or facade. The religious sanctuaries were of different denominations and represented both the grand cathedrals and modest neighborhood churches. In the early twentieth century, American painters, such as Gifford Beal and Metcalf, used the image of an old rural church surrounded by elms as a symbol of tradition.[20] Hassam utilized this motif more than his colleagues and even transferred it to the city, as in *St. Marks in the Bowery,* 1910. While trees are absent from many of the Manhattan images, Hassam still conveyed a suggestion of cultural continuity by the medieval-revival architecture of most of the religious sanctuaries.

Hassam created more urban views in the 1890s than during any other decade, and his development up until then was marked in 1899 by the publication of *Three Cities.* Devoted entirely to his views of New York, Paris, and London, this picture book signified the end of his first phase of New York imagery. The views of Manhattan that had come from Hassam's brush for almost a decade were temporarily disrupted by the artist's travels in Europe and, upon his return to America, by his preoccupation with other subject matter. When Hassam resumed exploring the city after 1900, he did so with fresh eyes and discovered that New York was no longer the quaint town he had known. The transformation of the city into a congested metropolis dominated by soaring towers had begun. Recent technological advancements—weight-bearing steel skeleton frames and passenger elevators—enabled the construction of buildings skyward and offered a solution to the increasing problem of high land values in lower Manhattan.

Early on, Hassam had revealed an interest in urbanization. In Paris, he followed in the footsteps of the Impressionists, painting the 8th arrondissement, a section that had undergone recent development, and upon his return home recorded the newly

21

James A.M. Whistler, CHELSEA SHOPS, early 1880s
Oil on wood, 5⅜ x 9⅜ inches
Freer Gallery of Art
Smithsonian Institution, Washington, D.C., 02.149

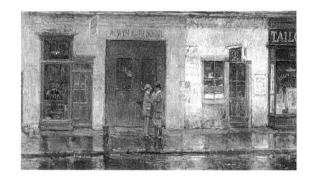

LITTLE COBBLER'S SHOP, 1910
Oil on canvas, 16⅝ x 30½ inches
© Addison Gallery of American Art
Phillips Academy, Andover, Massachusetts
All Rights Reserved

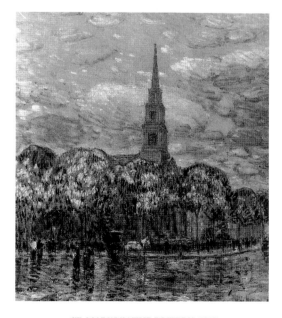

ST. MARKS IN THE BOWERY, 1910
Oil on canvas, 26 x 24 1/16 inches
Yale University Art Gallery
Mabel Brady Garvan Collection

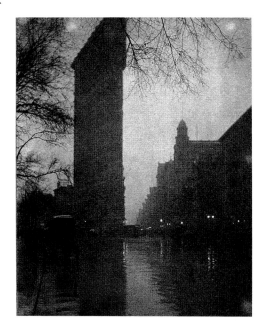

Edward J. Steichen, THE FLATIRON, 1905
Gelatin silver print, 9⅜ x 7½ inches
The Metropolitan Museum of Art
The Alfred Steiglitz Collection, 1933

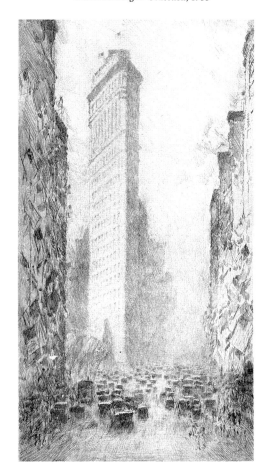

WASHINGTON'S BIRTHDAY, 1916
Etching, 13½ x 8¼ inches
Amon Carter Museum, Fort Worth

constructed Back Bay quarter on the fringes of Boston.[21] Recent additions to the Manhattan scene included imposing edifices built in revival architectural styles: the neoclassic Stock Exchange Building on Broad Street, completed in 1903 and painted by Hassam in 1907; the large crenelated armory in the foreground of *Church of the Paulist Fathers*, 1907, built for the New York National Guard only six years prior to the painting; and St. Thomas, completed in 1916, a few years before Hassam depicted it in a lithograph. New banks, department stores, and hotels also frequently appeared in his images.

It was the tall buildings that most drastically transformed the city and made it a truly modern, American metropolis. New York's first era of high rises began with the construction of the Washington Building in 1884 and lasted well into the 1910s. The Park Row Building (1899), the Fuller Building, better known as the Flatiron Building (1902), and the Woolworth Building (1913) were often in the news and depicted by many artists. The beauty of the skyscraper was a hotly debated issue, and not until the second decade of the twentieth century did a positive attitude replace initial skepticism. Traditionalists such as Chase said the tall buildings were ugly and represented the crassness of commercial enterprise, while proponents, such as photographer Alfred Stieglitz and critic Sadakichi Hartmann, perceived of them as symbols of a new nationalist spirit, one that extolled a dynamism and power distinct from European culture. Numerous articles about the tall buildings and the changing face of the city that appeared during the 1890s in *Scribner's, The Century,* and other popular magazines established a favorable climate for the depiction of skyscrapers. Pennell illustrated John Van Dyke's 1909 book *The New New York,* and he and Hassam were among the foremost early delineators of the modern skyscraper city.

For the first three decades of the century, the destruction of old buildings and the construction of new, taller ones in their place was a favorite subject for artists and photojournalists. Hassam was well aware of such activity and the disruption it caused, for he wrote in 1910, "Paris is a huge Coney Island...The town is all torn up like New York. Much building going on. They [the French] out American the Americans!"[22] Yet, he paid little attention to the actual process of erecting skyscrapers or the other engineering wonders of the city, such as the Brooklyn Bridge, which had opened to much fanfare in 1883. Interestingly, Hassam's one major exception, *The Hovel and the Skyscraper,* 1904, was actually a scene of the construction of a parish house rather than a high rise.[23]

Many of the skyscrapers appearing throughout Hassam's views can be identified by their distinctive silhouettes. Although the artist depicted the new structures, he often ignored the most famous examples: for instance, the unusual prowlike shape of the Flatiron Building at the southern edge of Madison Square inspired a host of images, but rarely appears in Hassam's oeuvre, even though the square had served as the setting for a number of his earlier scenes. The artist did not like to focus on a single high rise, for he thought the individual skyscraper was not "a marvel of art," but "a wildly formed architectural freak." Fellow artist Giles Edgerton agreed, explaining that the towers depended on their environment, "the old Gothic church..., the green park, the wide harbor," for their beauty.[24] Hassam's preference for anonymous skyscrapers, grouped with less progressive-looking structures, suggests that the artist desired to minimize the city's modern character. He perceived New York as an amalgam of tradition and modernity, truly "the city of contrasts" as proclaimed by Van Dyke.[25]

25

As early as 1898 Hassam noted, "From the tops of the enormous buildings one can get magnificent sweeps along the rivers and over the tops of the buildings."[26] Yet his panoramic skylines were sporadic, dating from the second decade of the century, when he would occasionally travel across the Hudson or East River to observe Manhattan from New Jersey or Brooklyn Heights. Hassam also recorded the roofs of the many tall structures seen from his studio building, but these were usually partial views of the city. In *Skyscrapers, Sunset,* 1918, Hassam set the towers against a sky of brilliant yellows, golds, and oranges, hues that underscore the vitality and boldness of the city. But this sketch was exceptional. Hassam's attitude toward skyscrapers revealed an ambivalence in sharp contrast to the enthusiastic adoption of the city's new appearance by more progressive artists, such as John Marin and Charles Sheeler.

Hassam's awareness of the skyline did determine the elevation from which he chose to look at the city and how he represented its altered spaces. While the bird's-eye view of *Union Square in the Spring,* 1896, was an exception to his early practice of painting at or near street level, it foretold his future habit of moving up to obtain a more expansive perspective.[27] The French Impressionists, encouraged by contemporary photography, preferred such height. Pissarro had looked down into the Place du Théâtre Français from a high elevation and transformed the Paris intersection into a flat arrangement of curvilinear shapes. In two paintings from 1904 — *The Hovel and The Skyscraper* and *Across the Park* — Hassam treated Central Park in similar compositional terms, but retained the horizon line and a degree of aerial perspective.

Writers and artists began to conceive of the thoroughfares, especially Fifth Avenue, as sublime canyons, since the rows of skyscrapers appeared to form continuous high walls of a valley. The tightly compacted financial district attracted numerous artists.[28] *Lower Manhattan,* 1907, was one of the first paintings in which Hassam utilized an extremely elevated vantage point to emphasize the city canyons. Hassam heightened the sense of soaring verticality by contrasting the buildings with the street traffic: teeming crowds of tiny figures become mere dabs of paint. His replacement of specific middle-class strollers with throngs of unidentified people indicated the anonymity of the new urban lifestyle and, perhaps, also signified Hassam's acknowledgment of the democratization of New York. The artist's new interpretation of the city achieved an iconic status in his many paintings and prints of Fifth Avenue.

Van Dyke wrote that in the "new New York" there was a "a great movement going on ... a surge of struggling humanity; ... a great war, the metallic-electric hum of power in action."[29] Hassam agreed. He had always been fascinated by the movement of people, and the increase in population merely heightened his belief that the city's beauty was derived from its "energy, power, humanity." The 1898 consolidation of the separate cities of Brooklyn and New York with the Bronx, Queens, and Staten Island encouraged residents of outlying areas to work in Manhattan. An extensive mass-transit system was needed to support the timely flow of commuters: in the 1870s, rapid elevated train lines proliferated, but not until 1904 was the subway opened and the entire system electrified. By then, the concept of a rush hour had begun. While Marin and Max Weber fractured and tilted large edifices to suggest the explosion of urban vitality, Hassam utilized crowd and transportation motifs, a more traditional approach, to convey the fast pace.

Hassam's cityscapes are replete with mass-transit vehicles and date from his early interest in horse-drawn hansom cabs and omnibuses to the appearance of double-

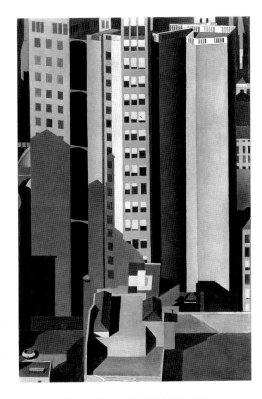

Charles Sheeler, SKYSCRAPERS, 1922
Oil on canvas, 20 x 13 inches
The Phillips Collection, Washington, D.C.

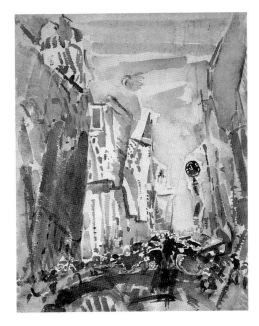

John Marin, MOVEMENT, FIFTH AVENUE, 1912
Watercolor, 17 x 13¾ inches
© 1993 The Art Institute of Chicago
Alfred Stieglitz Collection 1949.554
Photograph by Kathleen Culbert-Aguilar, Chicago

decker motor buses along Fifth Avenue in 1907. The Union Square cable car line that became notorious as "New York's most dangerous crossing" is in the lower center of Hassam's *Winter in Union Square,* early 1890s. But Hassam seemed most in awe of American engineering feats in *The El, New York,* 1894: totally uncharacteristic of the artist is the sense of the raw power of technology, conveyed through the sharp diagonal thrust of the elevated structure and the intense blue pigment. The elevated train system continued to appear in Hassam's urbanscapes, but never again did the artist demonstrate such appreciation of its modernity. 16

Yet Hassam's attitude toward the new city continued to remain problematic, as evidenced by his numerous romantic interpretations. To make the eccentric height and angularity of the skyscrapers seem less bizarre and more familiar, writers described them in terms analogous to nineteenth-century landscape and nature motifs.[30] In 1907, Henry James published an essay on the American scene in which he compared the New York skyline to a "loose nosegay of architectural flowers" and characterized the skyscraper as the "'American beauty,' the rose of interminable stem."[31] The same year, an unidentified reviewer for *The Evening Post* noted that Hassam "garlands the skyscrapers with rosy tints that suggest the flowers of Spring."[32] And as late as 1917, Hassam used floral terms in the title of a painting, *The New York Bouquet: West Forty-Second Street,* to refer to one of these long-stem beauties—the Bush Terminal Building then under construction between Sixth and Seventh avenues. 32

Often Hassam shrouded the city in shadowy twilight or a mist of inclement weather.[33] By obscuring the hard edges of city buildings, Hassam and other American artists rejected the urbanization and industrialization that they felt polluted the visual environment. In turn-of-the-century United States, Tonalists presented their subjective view of reality delicately tinted and slightly out of focus, as if seen through a gauze veil, thereby creating a quiet mood that suggested their nostalgia for a past era. Critics realized that Hassam's poetic hazes of gold, rose, and lavender hues "deprived [the skyscraper] of its rawness and effective realism."[34]

The electrical illumination of Manhattan greatly transformed the city at night. According to Hassam, these millions of electric lights gave the city a crass appearance, like "a gigantic cut-rate drug store." So he preferred dusk to late night. With only "a few flickering lights," the shadowy twilight would suggest "a magical evocation of blended strength and mystery." Nocturnal scenes were particularly popular with pictorial photographers, and there is a possibility that Hassam may have been encouraged by them, since he was familiar with their work and felt that in some circumstances the camera had an advantage over the painter.[35] But it was Whistler's innovative *Nocturnes* that were the ultimate source for Hassam's twilight views. Whistler was not concerned with capturing light effects of a specific time of day, but rather sought to evoke a harmonious mood; by limiting his palette to low-keyed tones and eliminating detail, he placed the emphasis on suggestion rather than description. Whistler presented his art-for-art's-sake theories publicly in London in 1885 and later published them as the "Ten O'Clock" lectures; Hassam read the lectures several times.[36] Whistler's belief in the artist's right to select from nature and his images of a city at night forecast the character of not only Hassam's evocative twilight images, but also his snow scenes.

Twachtman became the master of snowy landscapes and Hassam, of snowy urbanscapes. While frosty winters characteristic of the northeastern United States were

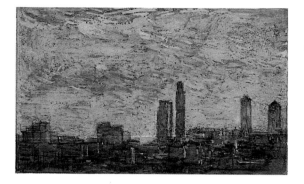

SKYSCRAPERS, SUNSET, 1918
Oil on panel, 5¼ x 9 inches
American Academy and Institute of Arts and Letters, New York
Bequest of Childe Hassam

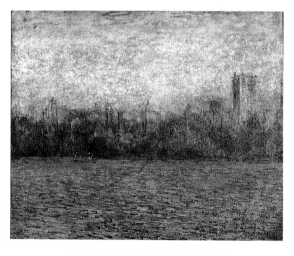

OCTOBER HAZE, MANHATTAN, 1910
Oil on canvas, 25 x 30¼ inches
Collection of Mr. and Mrs. Gerard Manolovici
Courtesy of Sotheby's, Inc., New York

visually appealing to American Impressionists, it was probably Whistler's fascination with the design potential of white paintings that inspired Americans to explore the theme. In such canvases as Hassam's *Late Afternoon, New York, Winter,* 1900, the color, atmosphere, design, and mood derived from them became paramount. Only in such twilight and snow urbanscapes did Hassam move far from his early interest in anecdote and the perceptual realism of Impressionism to approach abstraction.

17

In 1907, Hassam executed the first painting of a group known as his Window series. In each canvas, Hassam depicted a young woman sitting or standing in a domestic interior before a large window and among polished furniture, folding screens, flowers and plants, and paintings and other *objets d'art.* The intimate interior was quite in vogue by the time Hassam fully explored it. In the 1880s, Chase began depicting his elegant New York studio and later his comfortable summer residence in Shinnecock on Long Island. But it was the Boston School, namely Edmund Tarbell and Frank Benson (both fellow members of The Ten), who became most identified with the image of women at home. Chase and the Boston painters emphasized the elegance and size of the women's residences, since the rooms were so spacious that significant expanses, usually the foreground of the composition, could be left empty of furniture. Hassam's interiors, on the other hand, reveal little of the actual chamber; the furniture and its inhabitant are compressed into a narrow area close to the window, as if the room were small. While Chase and Tarbell suggested the lifestyle of a comfortably large house, Hassam indicated the space restrictions that were characteristic of Manhattan dwellings. Indeed, the claustrophobic quality of his compositions is that of the modern urban apartment.

Hassam's Window series, which he continued to do until about 1922, not only represented New York lifestyle, but symbolized the new metropolis. Usually in Chase's and Tarbell's scenes, doors and windows were partially indicated from an oblique angle or not shown at all, their existence implied through the sunlight pouring into the chamber. In Hassam's interiors, the aperture is always a highly visible and significant element of the composition and the figure is presented in proximity to it. Hassam's window not only allowed sunlight into the chamber, but gave the inhabitant access to the view outside. And it is this prospect through the window, rather than the window per se, that is an essential element of the paintings. Views of multi-floor buildings, in compacted rows or clustered haphazardly, fill the entire rectangle of the windows in

28, 36 *The Table Garden*, 1910, and *Easter Morning,* 1921, while a dramatic skyline with

27 high rises forms a breathtaking backdrop to *The Breakfast Room, Winter Morning,* 1911. Even the curtain never obstructs the view, for the drapery is always of sheer material; instead, the curtain functions as an actual veil, serving the same purpose as the haze of snow and twilight in Hassam's exteriors.

35 The subtitle of *Tanagra,* 1918 — *The Builders, New York* — reveals that these images are about the construction of the modern city. In this interior, a woman admires an ancient Tanagra figurine, which during Hassam's time was highly admired and thought to represent the depiction of Roman citizenry. With the gesture of the model holding the statuary in her right hand in front of the window, Hassam juxtaposes the symbol of a past, democratic civilization with the icon of the new urban culture, the scaffolding of a skyscraper. By placing Chinese lilies on the windowsill Hassam further underscores the idea of urbanization through a nature analogy; as

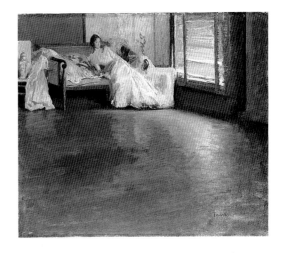

Edmund Tarbell, ACROSS THE ROOM, n.d.
Oil on canvas, 25 x 30⅛ inches
The Metropolitan Museum of Art
Bequest of Miss Adelaide Milton de Groot (1876 – 1967), 1967

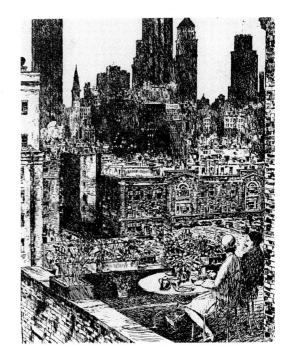

NEW YORK, 1931
Etching, 12¾ x 10⅜ inches
Private collection

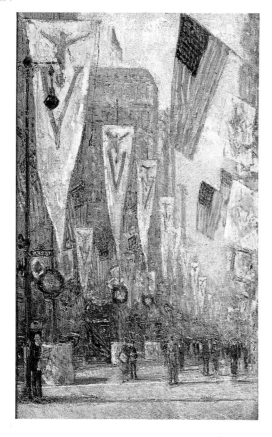

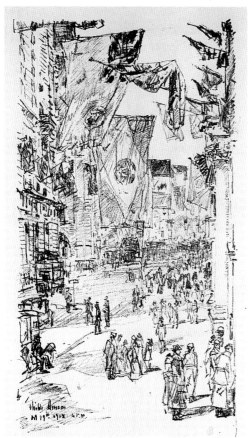

explained in the catalogue for his 1927 retrospective exhibition, "This picture is symbolic of the growth of New York, trying to come up in a beautiful way."[37] While the woman in *Tanagra* seems oblivious to what is occurring outside her home, in other paintings, women peer out of the aperture as if entranced by the birth of a new city. The two contradictory attitudes demonstrated by the models echo Hassam's own ambivalence.

Hassam had already fully established the conception of both his New York exteriors and interiors by the time of his flag paintings.[38] Exhibited as the Flag series for the first time in 1919, this group of oils represented Hassam's impressions of New York during World War I. The majority of the images were street views, although three were interiors in which sat the women—wives, mothers, sisters—who kept the homefires burning while their men fought. The decorations along Fifth Avenue during Preparedness Day on May 13, 1916, initially encouraged Hassam to explore the theme in paint. During the war years, the city was bedecked with flags and patriotic bunting hanging from windows and doorways and across the thoroughfares, patriotic gestures in support of our soldiers. At first only the American Stars and Stripes was flown, but after the United States entered the war, flags of the country's allies, especially those of England and France, were also displayed. Although national banners decorated office buildings, commercial structures, and private homes throughout the boroughs, the largest demonstrations were in Manhattan along the more active commercial thoroughfares. Fortunately for the aging Hassam, commanding displays occurred near his home and the businesses he frequented: the Union League Club (of which Hassam was a member and which he had painted in 1893) across from the Macbeth Gallery at Fifth Avenue and 39th Street appears in *Allied Flags, April 1917*, 1917, while 31 Milch Brothers (a frame shop) on the corner of 57th Street and Sixth Avenue is seen from the artist's studio in *Flags on 57th Street, The Winter of 1918*, 1918. The most 33 elaborate display, which was captured by Hassam in five canvases, occurred during the Fourth Liberty Loan Drive in the autumn of 1918, when each allied country was accorded a block along Fifth Avenue.

While the overall impression of hundreds of flags fluttering in the wind under sparkling sunlight was the stimulus for the flag paintings, during the three years Hassam devoted to the New York home front the flags increasingly came to symbolize the righteousness of the allied cause. Hassam was virulent in his dislike of Germany and ardent in his promotion of America as the land of liberty and democracy. He could devise no more appropriate imagery to underscore his beliefs than New York bedecked in the American and allied flags. The juxtaposition of the skyscraper city—emblem of the country's technological prowess—with the national banners—symbols of democracy—insured the meaning of the flag paintings. To demonstrate how important the war effort and America's role in the victory were to the artist, Hassam for once included himself in a New York scene; below the Stars and Stripes, near the center foreground of *Allied Flags, April 1917*, strolls the portly artist with a large portfolio 31 under his arm. He is on his way to find new sights to sketch, for Hassam's painted images of the city during the crisis were his contribution to the war effort.

Today it is easy to forget the significance of city iconography in Hassam's New York views when the sparkle of his bright sky and warm sun and the delicacy of his rain and snow are so visually appealing. Yet his urbanscapes are much more than

sumptuous Impressionist or evocative Tonalist paintings. They are visual records of the life of a city. History is always the course of events as perceived by the person telling the story. In Hassam's case, the transformation of America's premier metropolis was conveyed with enthusiasm, love, and regret. But whether Hassam portrayed New York as a picturesque town during its last genteel years, or as a rising young cosmopolitan center, or as the emblem of the most technologically advanced country in the world, what was most important to him was to capture its spirit. As he once remarked,

> The portrait of a city...is in a way like the portrait of a person—the difficulty is to catch not only the superficial resemblance but the inner self. The spirit, that's what counts, and one should strive to portray the soul of the city with the same care as the soul of a sitter.[39]

Ilene Susan Fort

VICTORY WON, 1919
(Also known as VICTORY DAY)
Oil on canvas, 36 x 22 inches
American Academy of Arts and Letters, New York

AVENUE OF THE ALLIES, 1918
Lithograph, 18 x 11½ inches
Los Angeles County Museum of Art
Gift of Mrs. Childe Hassam

Notes

1. Childe Hassam interview in "New York the Beauty City," *The Sun* [New York], February 23, 1913, p. 16. Hereafter, unless noted, all Hassam quotes are from this article.

2. As noted and quoted by Kathleen Burnside, "New York in the 1890s," *Sotheby's Art at Auction, 1988 – 89* (New York: Sotheby's, 1989), p. 170.

3. His excursions away from the metropolis were usually allocated to the summer months when the city was interminably hot. The artist then turned to painting rural landscapes in New England and Long Island or undertook excursions in search of picturesque subject matter or to visit patrons, as when he traveled to Europe in 1897, 1898, and 1910, and to the West Coast in 1904, 1908, 1914, and 1927.

4. Jennifer A. Martin Bienenstock, "Childe Hassam's Early Boston Cityscapes," *Arts Magazine* 55 (November 1980): 170.

5. A. E. Ives, "Talks with Artists: Mr. Childe Hassam on Painting Street Scenes," *Art Amateur* 27 (October 1892): 116.

6. Sadakichi Hartmann, "Art Talk," *The Criterion* (January 8, 1898): 17.

7. Quoted in Ives, *Art Amateur* 27 (October 1892): 116 – 117.

8. Marianne Griswold Van Rensselaer, "Fifth Avenue," *The Century* 47 (November 1893): 12.

9. Childe Hassam interview by De Witt McClellan Lockman, January 31, 1927, p. 23 of transcript, Lockman Papers, New-York Historical Society (on microfilm, Archives of American Art, roll 503, no fr. number).

10. Hassam lived for a time at the Chelsea Hotel on 23rd Street, the Rembrandt on 57th Street a few blocks away from Central Park, and for about five years during the first decade of this century as far north as 67th Street off of Central Park West.

11. Van Rensselaer, *The Century* 47 (November 1893): 14.

12. *Ibid.*, p. 10.

13. Adeline Adams, *Childe Hassam* (New York: American Academy of Arts and Letters, 1938), p. 70.

14. Eliot Clark, "Childe Hassam," *Art in America* 8 (June 1920): 173.

15. The one exception, *The Chinese Merchants*, 1909

(Freer Gallery of Art, Smithsonian Institution, Washington, D. C.) was actually of the Chinese quarter of Portland, Oregon, not New York; however, he did treat it compositionally in the same manner as he had already depicted the humble New York neighborhood in *The Messenger Boy,* 1903 (pl. 21).

16. For example, Israel L. White, "Childe Hassam—A Puritan," *International Studio* 45 (December 1911): xxix.

17. Lockman interview, February 2, 1927, p. 5 of transcript, Lockman Papers.

18. On the back of the stretcher of *The Messenger Boy* is written "little shoemaker's shop."

19. David Park Curry, *Childe Hassam: An Island Revisited,* exhibition catalogue, Denver and New York: Denver Art Museum in association with W. W. Norton & Co., 1990, p. 148.

20. Michael Kammen, *Meadows of Memory: Images of Time and Tradition in American Art and Culture,* Tandy Lectures in American Culture, Amon Carter Museum, Fort Worth, no. 11 (Austin: University of Texas Press, 1992), p. 165.

21. Carol Troyen, *The Boston Tradition: American Paintings from the Museum of Fine Arts, Boston,* exhibition catalogue, New York: American Federation of Arts and Museum of Fine Arts, Boston, 1980, pp. 164, 166.

22. Childe Hassam to J. Alden Weir, Paris, July 21, 1910, Hassam Papers, American Academy and Institute of Arts and Letters, New York (on microfilm, Archives of American Art, roll NAA2, fr. 66).

23. Donelson F. Hoopes, *Childe Hassam* (New York: Watson-Guptill Publications, 1979), p. 62.

24. Giles Edgerton, "How New York Has Redeemed Herself from Ugliness—An Artist's Revelation of the Beauty of the Skyscraper," *The Craftsman* 15 (January 1907): 469.

25. John C. Van Dyke, *The New New York: A Commentary on the Place and the People* (New York: Macmillan Co., 1909), p. 11.

26. Childe Hassam, quoted in "New York Beautiful," *Commercial Advertiser* [New York], January 15, 1898, p. 9.

27. According to a January 14, 1905, *New York Times* review of Hassam's Montross Gallery exhibition, this view of the square looking south may have been painted from the roof of the Everett House. John A. Kouwen-

hoven in *The Columbia Historical Portrait of New York* (1953), however, suggests that it was probably sketched from the building of the Century Company.

28. Hassam's composition and viewpoint are similar to a 1905 Brown Brothers photograph and Pennell's 1904 etching, *Lower Broadway.*

29. Van Dyke, 1909, p. 7.

30. Wanda Corn, "The New New York," *Art in America* 61 (July / August 1973): 60.

31. Henry James, *The American Scene* (1907; New York: Scribner's, 1946), p. 77.

32. "A Leader of the Open-Air School," *Evening Post* [New York], December 12, 1907 clipping, in Hassam Papers (on microfilm, Archives of American Art, roll NAA1, fr. 537).

33. Hassam's late turn to night scenes may have been, at times, encouraged by the weather, for he wrote to Weir in July of 1906 that the inclement weather at Old Lyme had forced everyone there to do "moonlights."

34. Joseph Edgar Chamberlin, "Child Hassam's Pictures," *New York Evening Mail,* December 18, 1907, clipping in Hassam Papers (on microfilm, Archives of American Art, roll NAA1, fr. 543).

35. Hassam felt that the camera could produce better impressionist scenes because of the instantaneous nature of the machine. He was quoted in Sadakichi Hartmann, "Photographic Enquête," *Camera Notes* 5, no. 11 (April 1902): 236.

36. In 1903, Hassam wrote to Weir that he had just read the "Ten O'Clock" lectures for the first time in ten years and that he was particularly impressed by the truths of Whistler's ideas (letter, August 12, 1903, Hassam Papers [Archives of American Art, microfilm roll NAA2, fr. 68]).

37. *A Catalogue of an Exhibition of the Works of Childe Hassam,* New York: American Academy of Arts and Letters, 1927, p. 26.

38. The Flag paintings are the only aspect of Hassam's New York City imagery to have been analyzed in depth. For more details on them, see the author's *The Flag Paintings of Childe Hassam,* exhibition catalogue, Los Angeles and New York: Los Angeles County Museum of Art in association with Harry N. Abrams, Inc., 1988.

39. Hassam quoted in *The Sun* [New York], February 23, 1913, p. 16.

1
NEW YORK BLIZZARD, 1889
Oil on panel
4¾ x 8 inches
Courtesy of Kennedy Galleries, Inc., New York

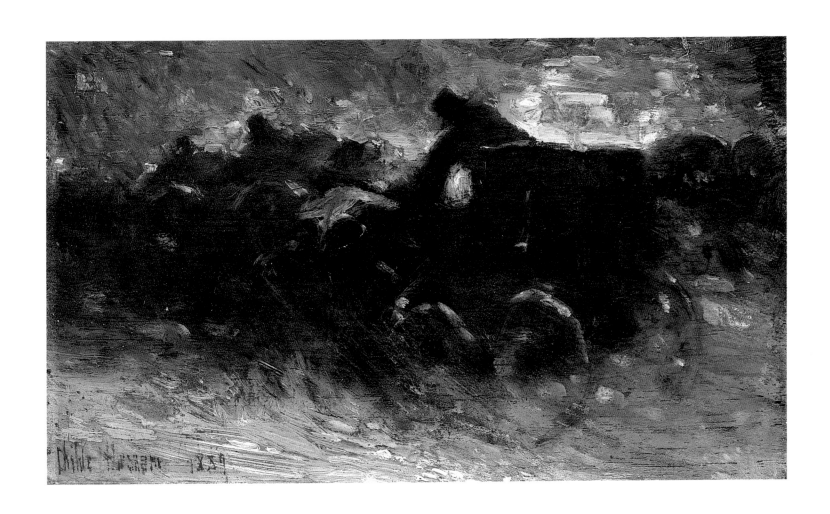

2
HORSE DRAWN CABS AT EVENING, NEW YORK, c. 1890
Watercolor and gouache on paper
14 x 17¾ inches
Berry-Hill Galleries, New York
Photograph courtesy of Christie's, New York

…clever canvas depicting coachmen under an electric light, with long
wet shadows and an impression of drizzling rain.

"Gossip of the Studios," *The Recorder* [New York], undated clipping, Childe Hassam Papers,
American Academy and Institute of Arts and Letters, New York
(on microfilm, Archives of American Art, roll NAAA-1, fr. 487).

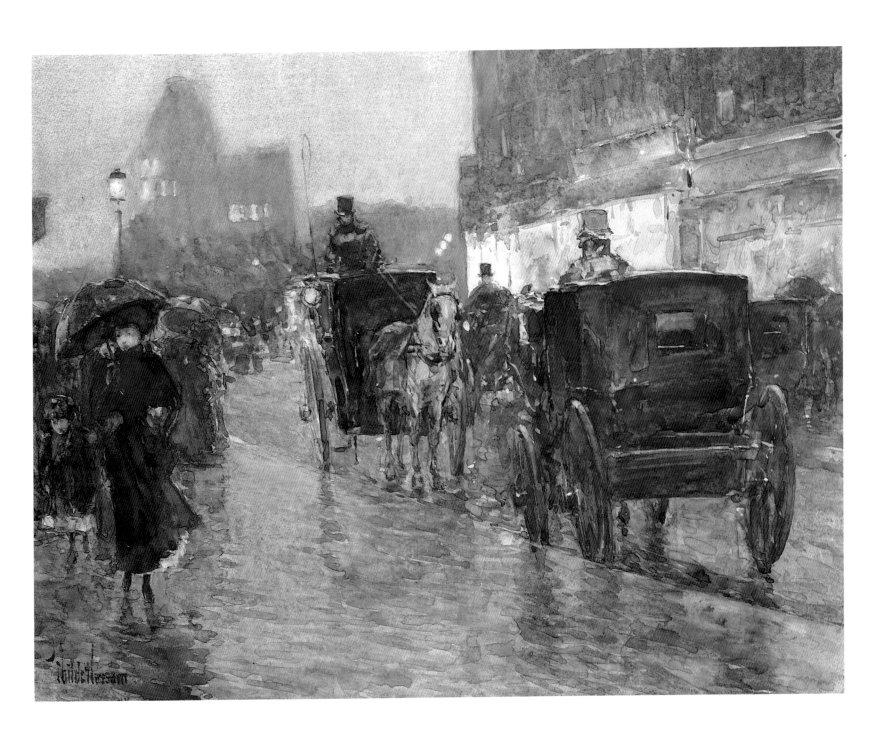

3
RAIN STORM, UNION SQUARE, 1890
Oil on canvas
28 x 36 inches
Museum of the City of New York
Gift of Miss Mary Whitney Bangs

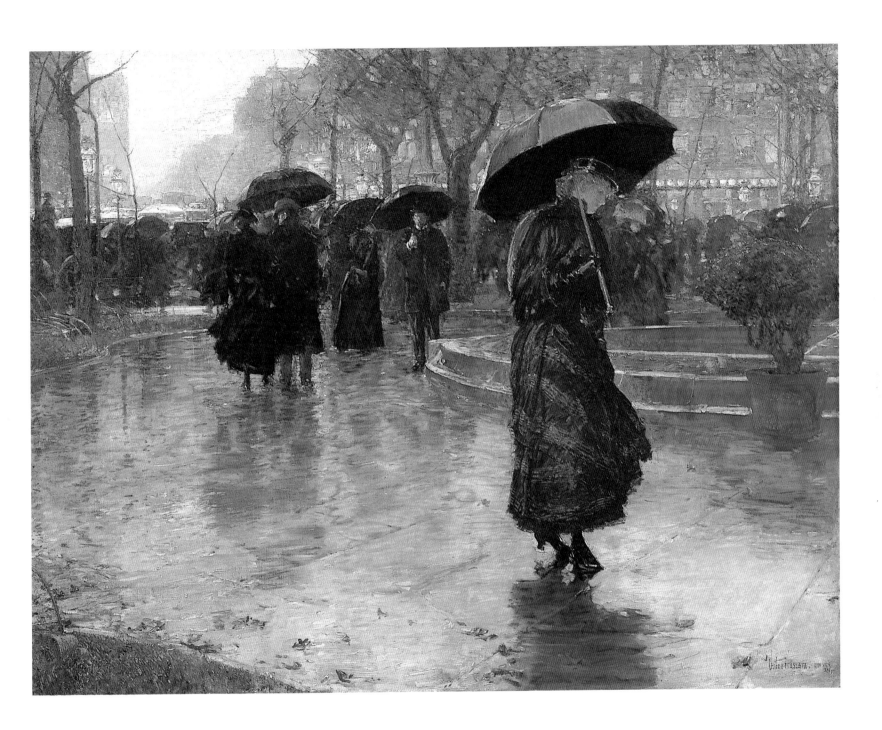

4
WASHINGTON ARCH, SPRING, 1890
Oil on canvas
27⅛ x 22½ inches
The Phillips Collection, Washington, D.C.

A couple of miles uptown is Washington Square, where...there are many
tramps,...a sprinkling of baby wagons and white-capped nurses; for
this is the boundary-line between very poor and crowded and very well-
to-do and roomy streets of homes—South Fifth Avenue, with its teem-
ing French, German, Irish, and negro population, ending against one
of its sides, and the true Fifth Avenue starting from another.

Marianne Griswold Van Rensselaer, "Picturesque New York," *The Century* 45
(December 1892): 174.

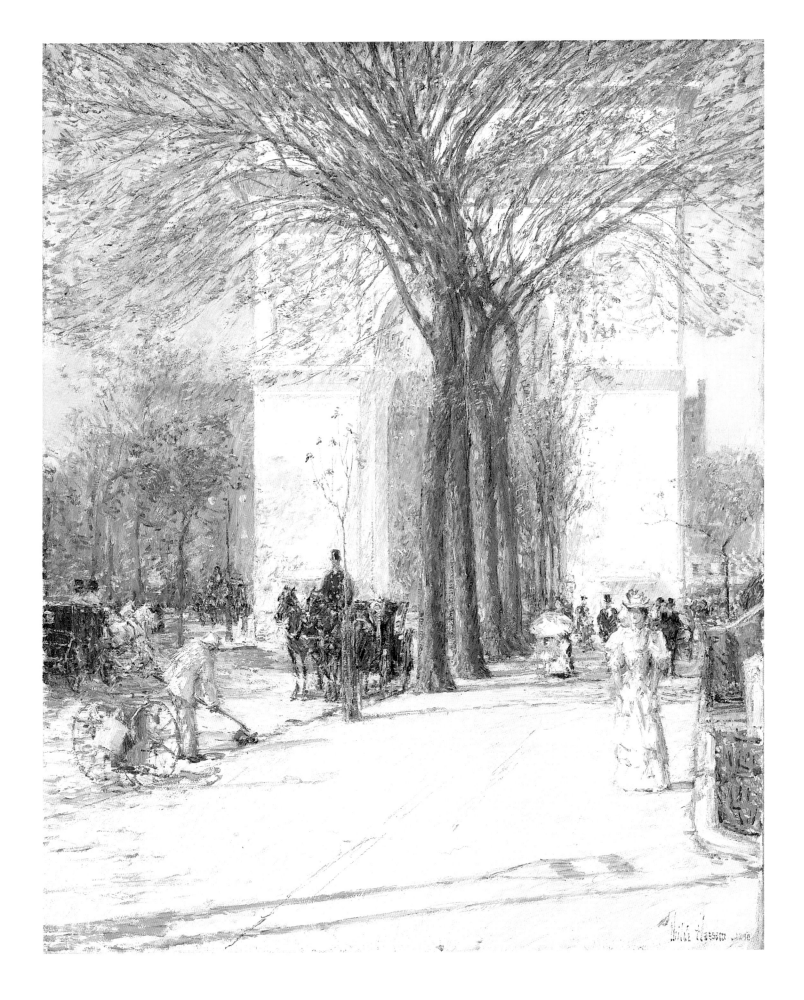

5
SPRING MORNING IN THE HEART OF THE CITY, 1890
Oil on canvas
18⅛ x 20¾ inches
The Metropolitan Museum of Art
Gift of Ethelyn McKinney, 1943
In memory of her brother, Glenn Ford McKinney

...is a thing to rejoice in, for the brilliant and sparkling way in which
the throng of figures and carriages, as well as the fresh verdure beyond
is rendered.

Review of Childe Hassam exhibition at Knoedler Gallery, unidentified newspaper clipping,
Hassam Papers, American Academy and Institute of Arts and Letters, New York
(on microfilm, Archives American Art, roll NAA-1, fr. 493).

Apartment-houses had not then been thought of, except to say that
Americans would never consent to live in such cramped, unhome-like,
and Frenchified things. When the Hotel Brunswick was evolved out of
certain modest dwelling-houses...it was counted very tall. But Mr.
Hassam shows you that it now looks modest itself against the cliff-like
background of the Knickerbocker apartment-house.

Marianne Griswold Van Rensselaer, "Fifth Avenue," *The Century* 47
(November 1893): 13 – 14.

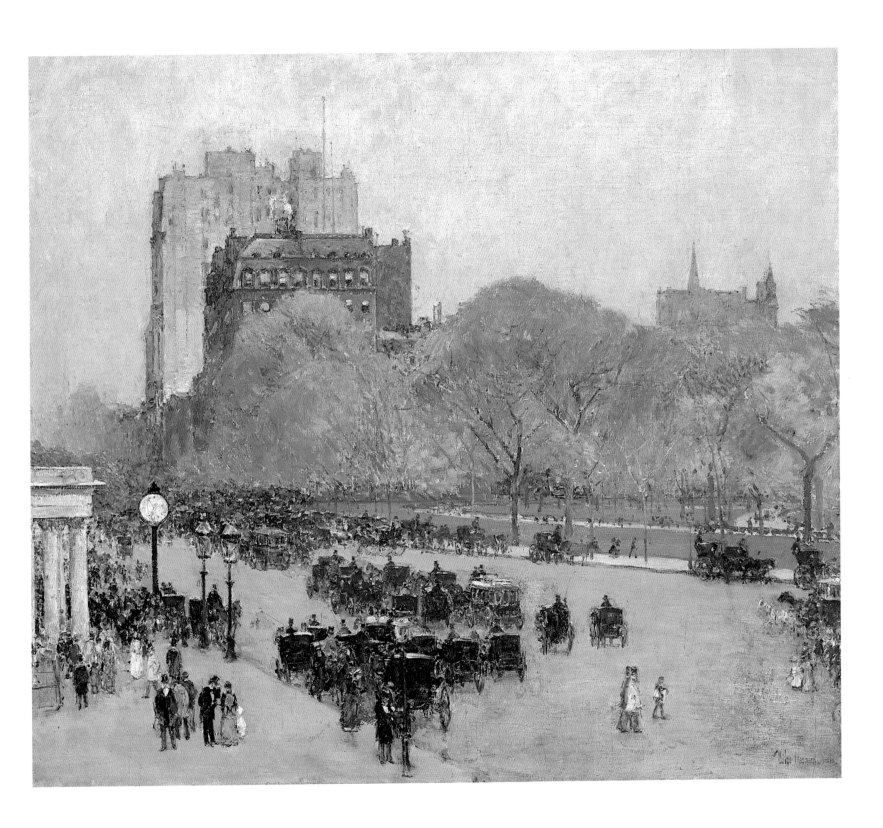

6
THE MANHATTAN CLUB, c. 1891
(also known as THE STEWART MANSION)
Oil on canvas
18¼ x 22⅛ inches
Santa Barbara Museum of Art
Gift of Sterling Morton for the
Preston Morton Collection

Few streets in the world are gayer, brighter, more attractive than is this
part of our best street [Fifth Avenue] when it is seen at its best. To begin
with, it has such a wonderful atmosphere—such a crystalline splendor
of thin, bright air, and pure brilliant light...throngs of...stately steeds
pulling stately and glistening coaches, filled with charming faces and
satisfying silken gowns.

Marianne Griswold Van Rensselaer, "Fifth Avenue," *The Century* 47
(November 1893): 14–15.

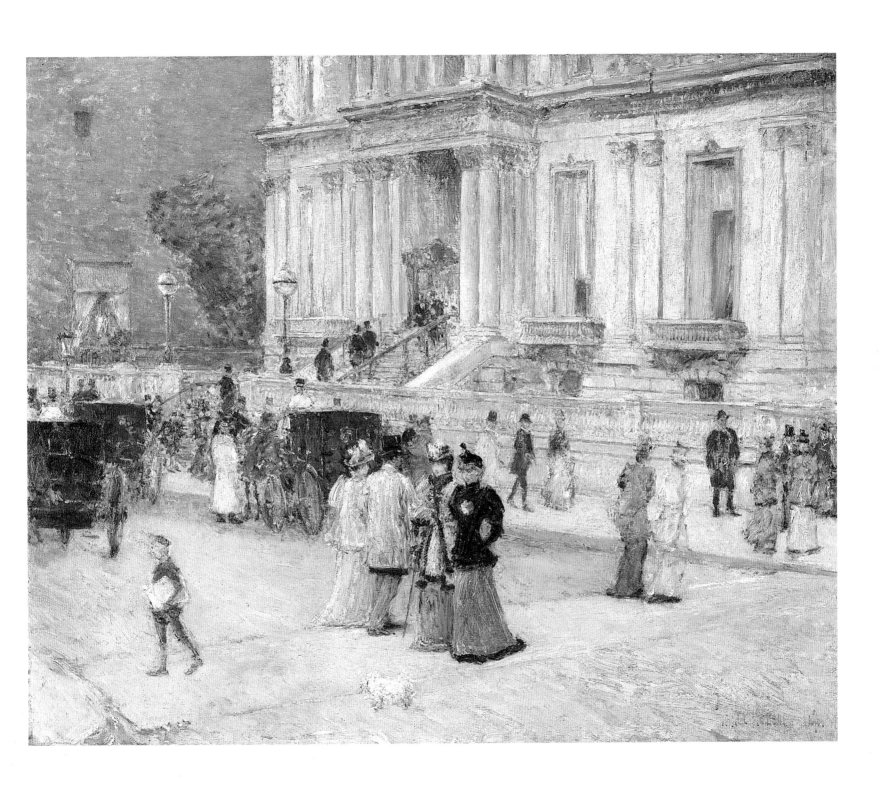

7
A SPRING MORNING, c. 1890-91
Oil on canvas
27½ x 20 inches
Berry-Hill Galleries, New York

They [people] have become so used to the molasses and bitumen school, that they think anything else is wrong. The fact is, the sort of atmosphere they like to see in a picture they couldn't breathe for two minutes. I like air that is breathable. They are fond of that rich brown tone in painting. Well, I am not, because it is not true....This blue that I see in the atmosphere is beautiful, because it is one of the conditions of this wonderful nature all about us.

Childe Hassam, quoted in A. E. Ives, "Talks with Artists,"
Art Amateur 27 (October 1892): 116.

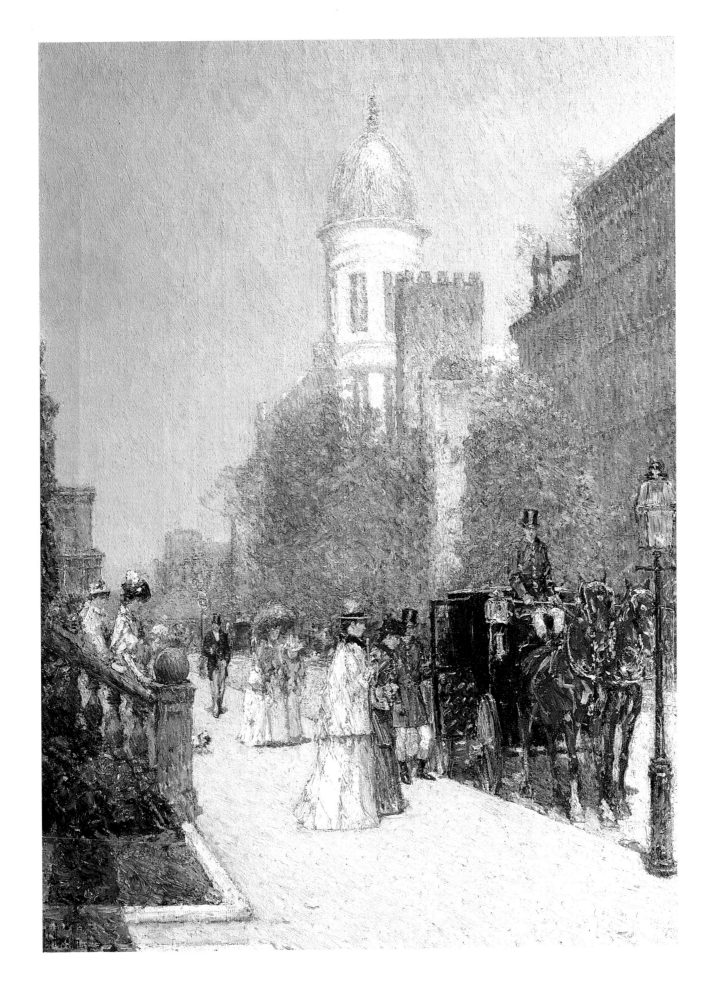

8
FIFTH AVENUE AT WASHINGTON SQUARE, 1891
Oil on canvas
22 x 16 inches
Thyssen-Bornemisza Collection
Photograph courtesy of Art Resource, New York

…when I think how things have happened elsewhere in New York, I
am ready to affirm that Washington Square has thus far led a reasonably
conservative life.

Marianne Griswold Van Rensselaer, "Fifth Avenue," *The Century* 47
(November 1893): 10.

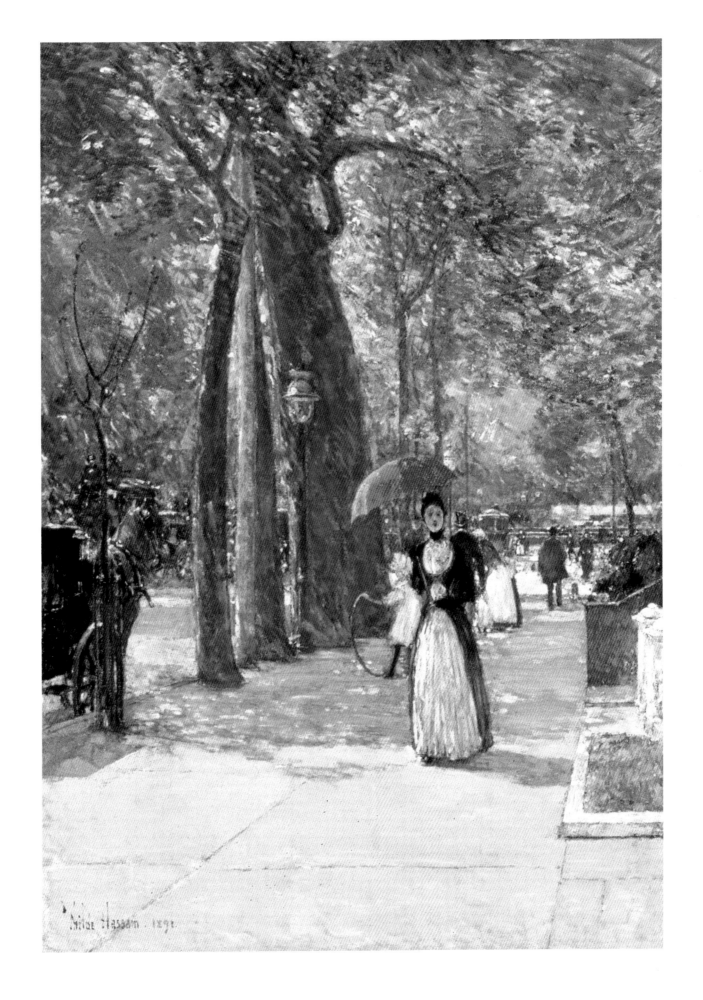

9
CAB STAND AT NIGHT, MADISON SQUARE, NEW YORK, 1891
Oil on panel
8¼ x 13¾ inches
Smith College Museum of Art, Northampton, Massachusetts
Bequest of Annie Swan Coburn (Mrs. Lewis Larned Coburn), 1934

There is no end of material in the cabbies. Their backs are quite as
expressive as their faces. They live so much in their clothes, that they
get to be like thin shells, and take on every angle and curve of their
tempers as well as their forms. They interest one immensely.

Childe Hassam, quoted in A. E. Ives, "Talks with Artists,"
Art Amateur 27 (October 1892): 116.

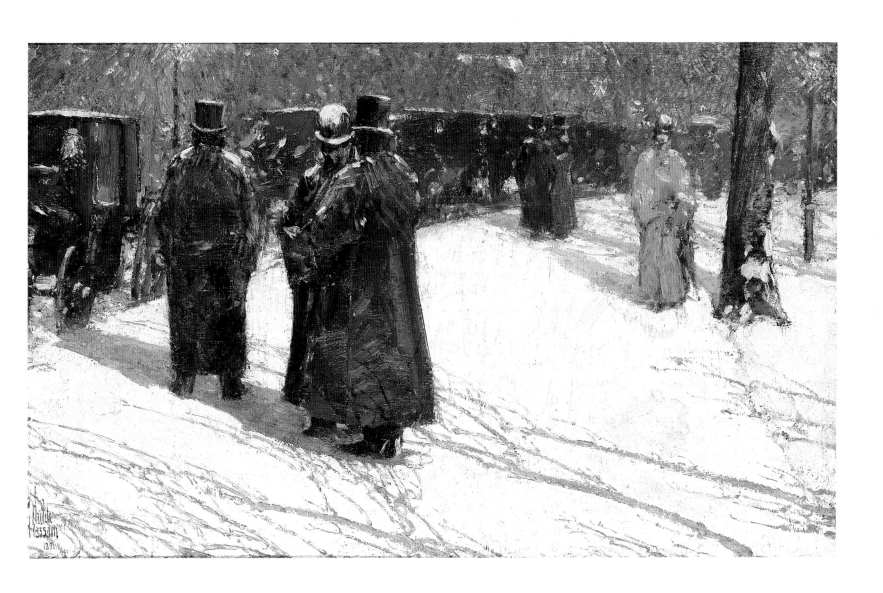

10
A WINTER DAY ON BROOKLYN BRIDGE, 1892
Watercolor and gouache en grisaille on paper
15¼ x 32¼ inches
Berry-Hill Galleries, New York

Up through Brooklyn and along the great bridges there is continuous
travel by trolley, motor, and foot, from early in the morning. Before
nine o'clock the tide is at its flood. Around the New York exit of the
Brooklyn Bridge the currents from many directions meet and mingle
to make a veritable whirlpool of humanity that circles and eddies, foams
and dashes, gets mixed up in a roaring swirl, then collapses in froth,
dissipates, and finally trickles away in small streams to various points
of the compass.

John C. Van Dyke, *The New New York* (New York: Macmillan, 1909), p. 67.

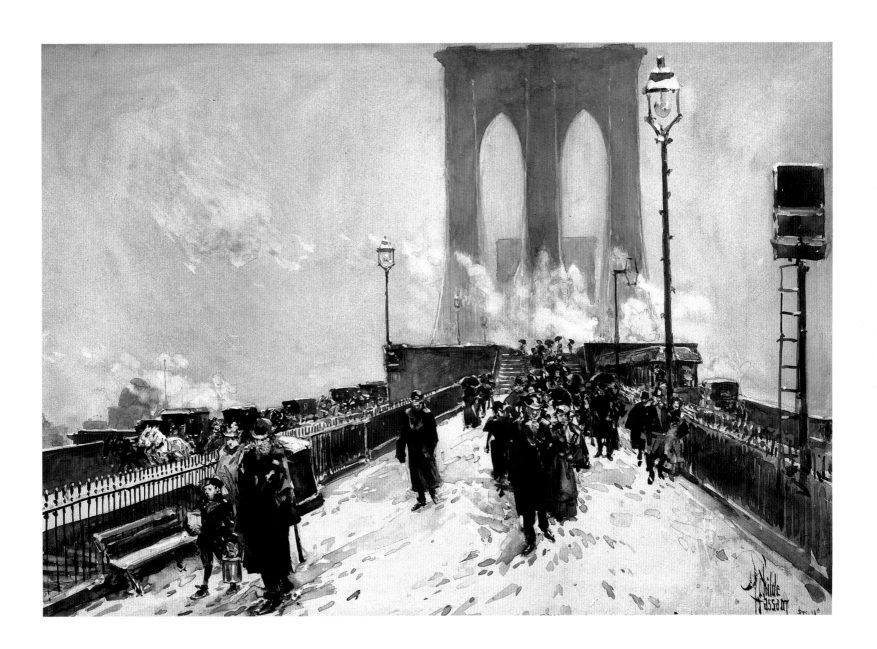

11
FIFTH AVENUE IN WINTER, 1892
Oil on canvas
21⅝ x 28 inches
The Carnegie Museum of Art, Pittsburgh
Purchase, 00.2

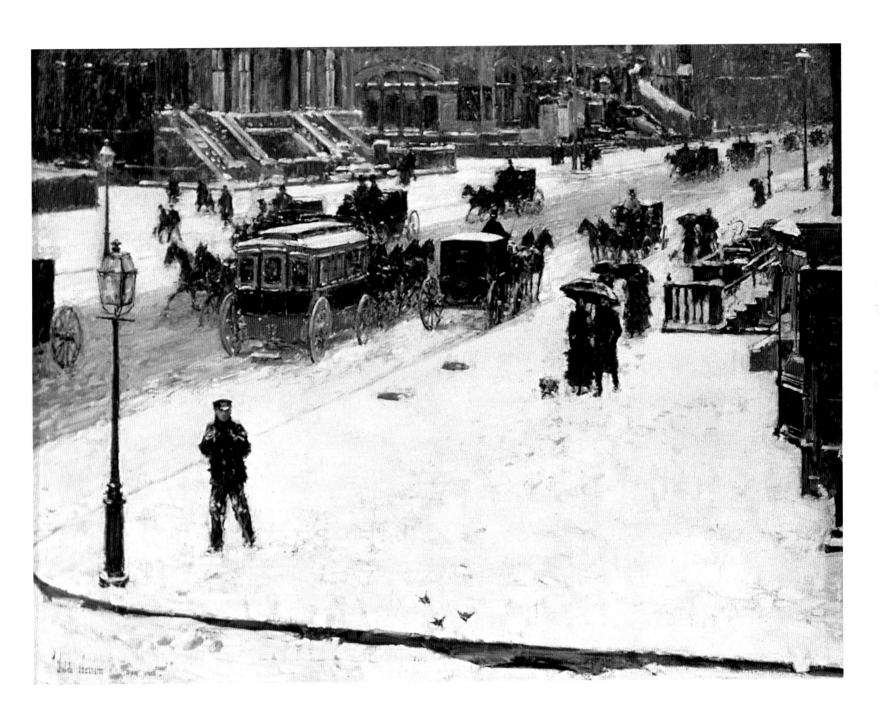

12
STREET SCENE, CHRISTMAS MORNING, 1892
Oil on panel
11¾ x 8 inches
Smith College Museum of Art, Northampton, Massachusetts
Bequest of Annie Swan Coburn (Mrs. Lewis Larned Coburn), 1934

New York women are sometimes the finest-dressed women in the world.
The are apt to overdress, but when they succeed they succeed
beautifully.

Childe Hassam, quoted in "New York Beautiful,"
Commercial Advertiser [New York], January 15, 1898, p. 9.

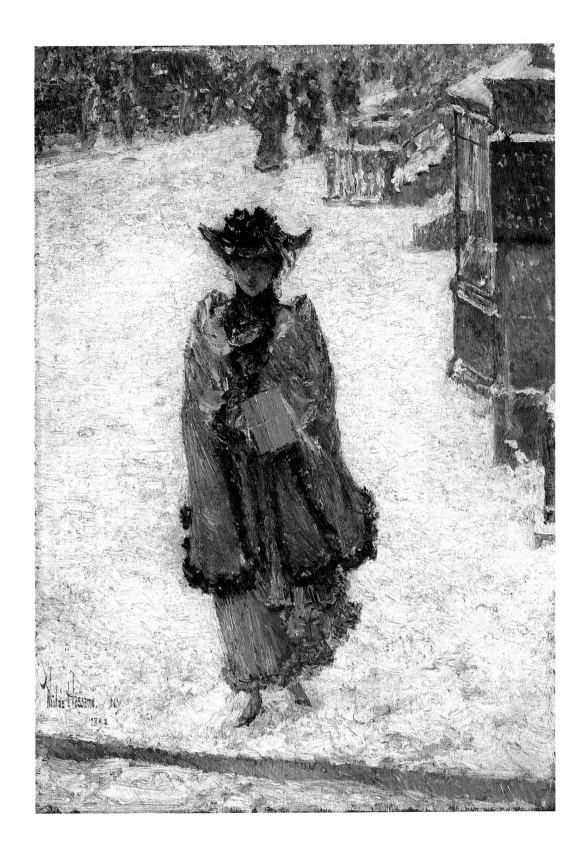

13
SUNDAY ON FIFTH AVENUE, n.d.
Watercolor on paper
30 x 19 inches
James Graham & Sons, New York

On Sunday, after church-time, the sauntering was very general. If you
knew any one worth knowing in New York, you were pretty sure to
find him on the Avenue [Fifth Avenue] then.

Marianne Griswold Van Rensselaer, "Fifth Avenue," *The Century* 45
(November 1893): 13.

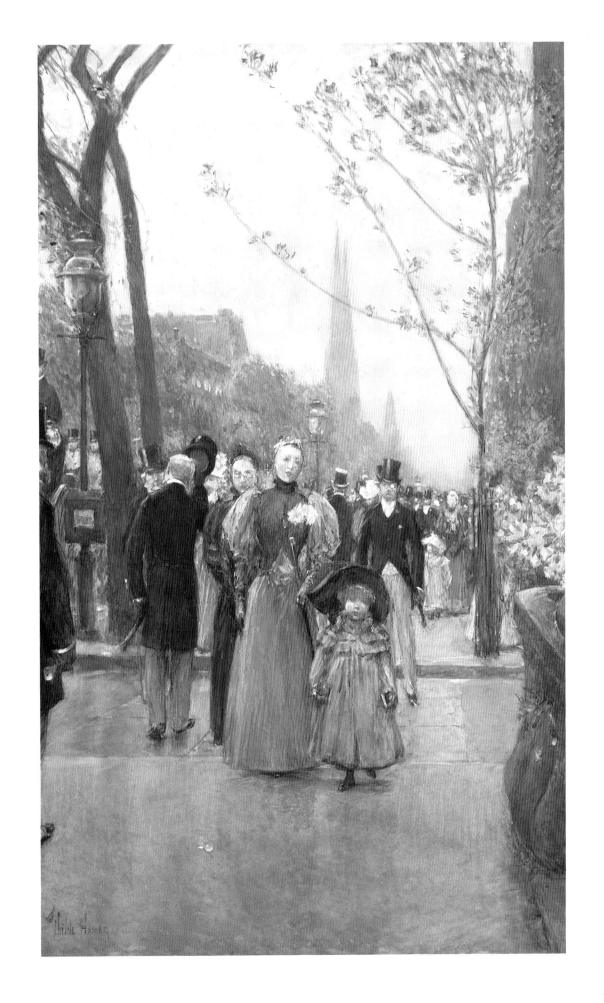

14
NEW YEAR'S NOCTURNE, 1892
Watercolor and gouache on paper
22 x 15 inches
The Shearson Lehman Brothers Inc. Collection
Photograph courtesy of Berry-Hill Galleries, New York

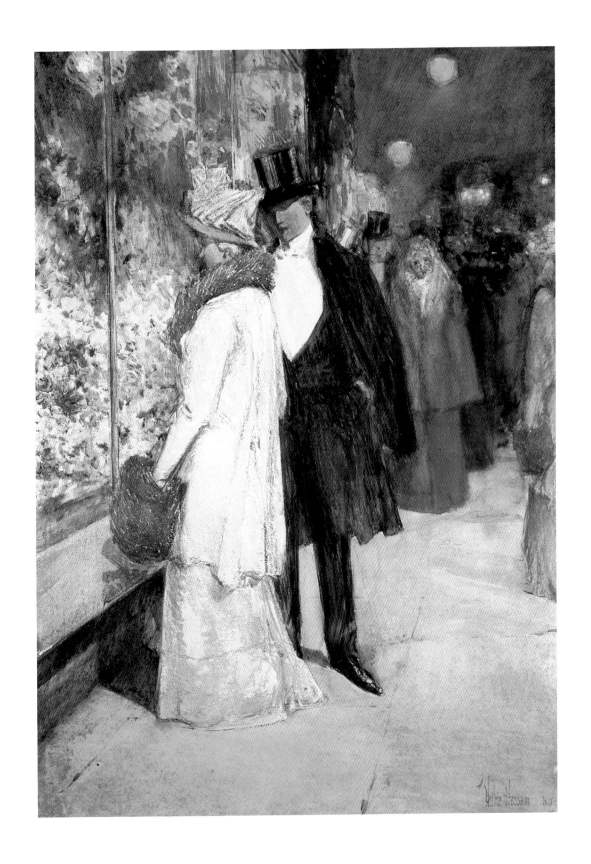

15
UNION SQUARE IN SPRING, 1896
Oil on canvas
21½ x 21 inches
Smith College Museum of Art, Northampton, Massachusetts
Purchased 1905

In the neighborhood of Union Square, with its rather depressing statuary
redeemed by Brown's spirited equestrian figure of Washington, the
painter depicted the truth and beauty of the commonplace in canvases
such as his joyous Spring in Union Square.

Adeline Adams, *Childe Hassam* (New York: American Academy of
Arts and Letters, 1938), p. 61.

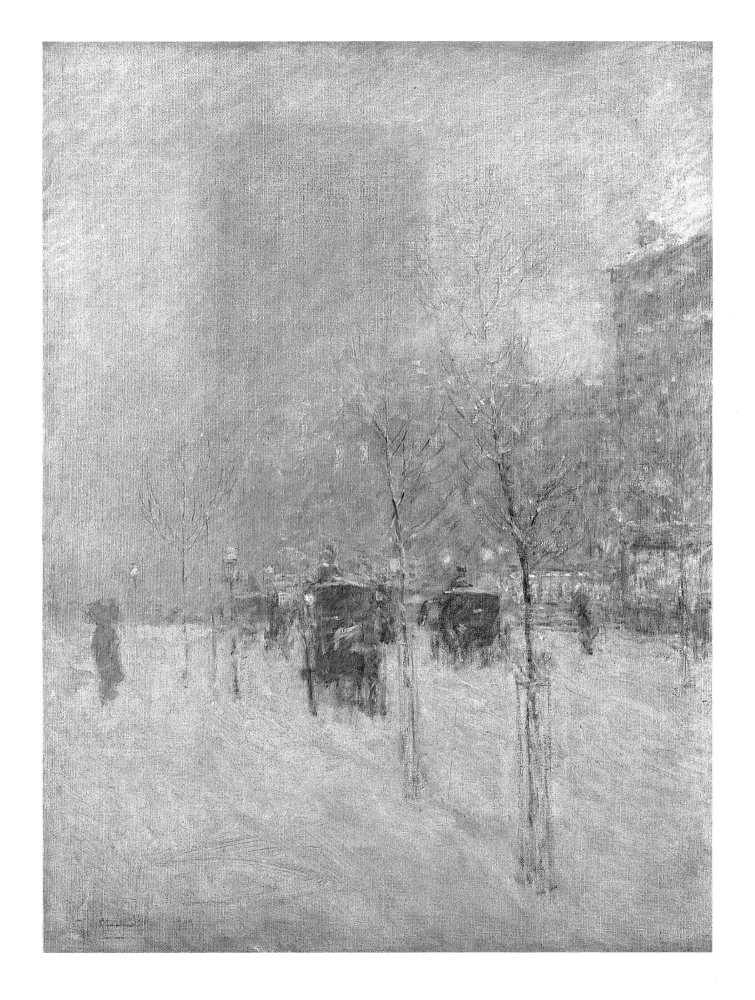

18
A NEW YORK BLIZZARD, n.d.
Pastel on paper
13⅞ x 9⅜ inches
Isabella Stewart Gardner Museum, Boston

He painted with equal zest winter's snarling blizzard, or one of those
prismatic snowfalls of quietness, in which some of the crystals drop softly
to earth, while others have wings for flying upward.

Adeline Adams, *Childe Hassam* (New York: American Academy of
Arts and Letters, 1938), p. 61.

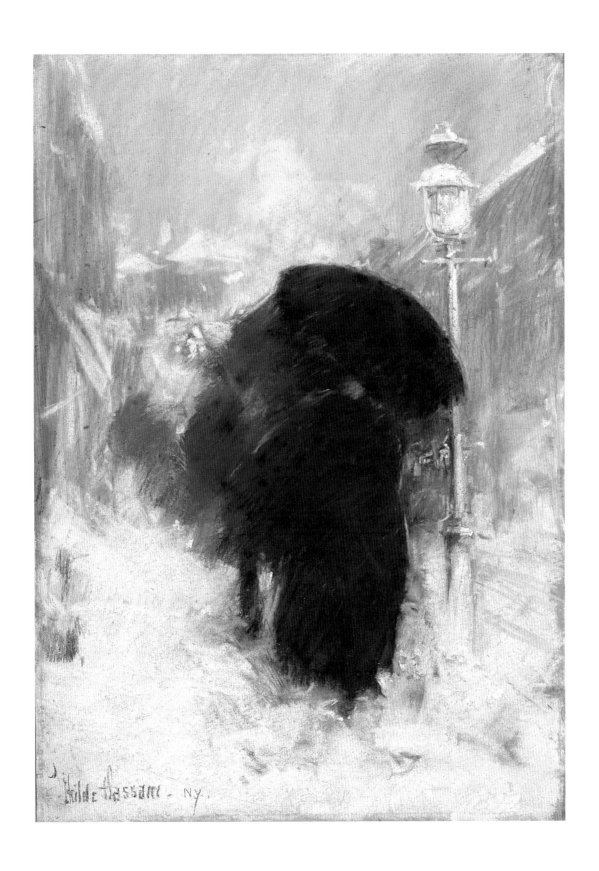

19
FIFTH AVENUE NOCTURNE, c. 1895
Oil on canvas
24¼ x 20¼ inches
The Cleveland Museum of Art
Anonymous gift, 52.538

If I want to observe night effects carefully, I stand out in the street with
my little sketch-book, draw figures and shadows, and note down in
colored crayons the tones seen in the sky, in the snow, in the reflections
or in a gas lamp shining through the haze.

Childe Hassam, quoted in A. E. Ives, "Talks with Artists,"
Art Amateur 27 (October 1892): 116.

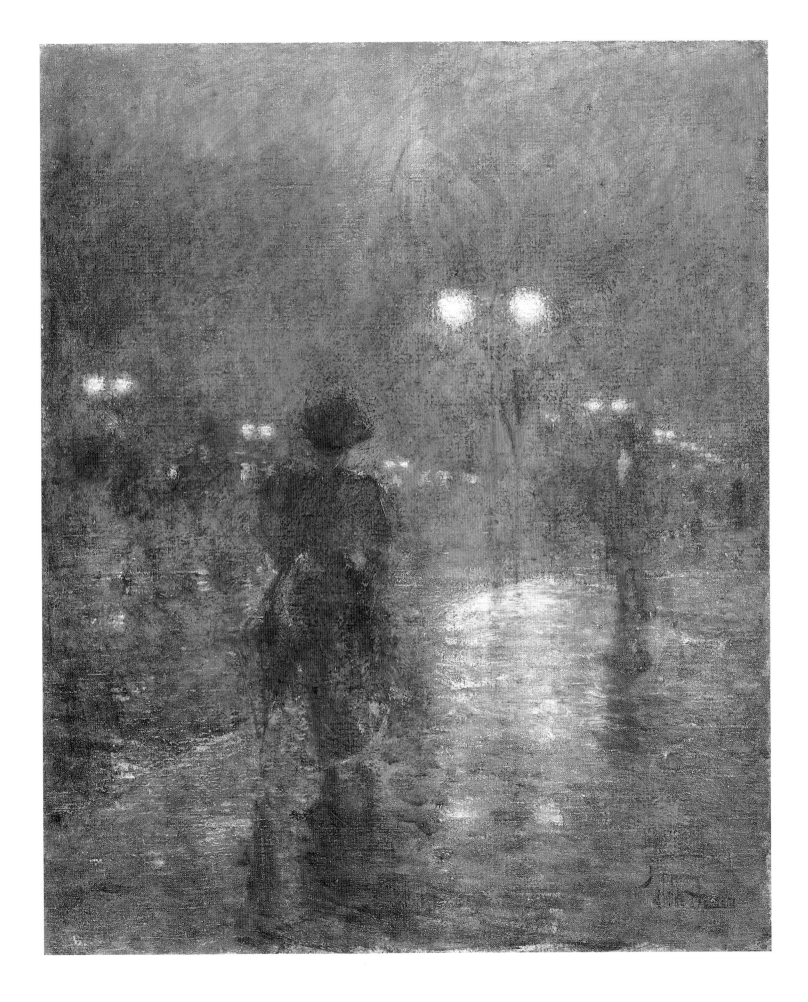

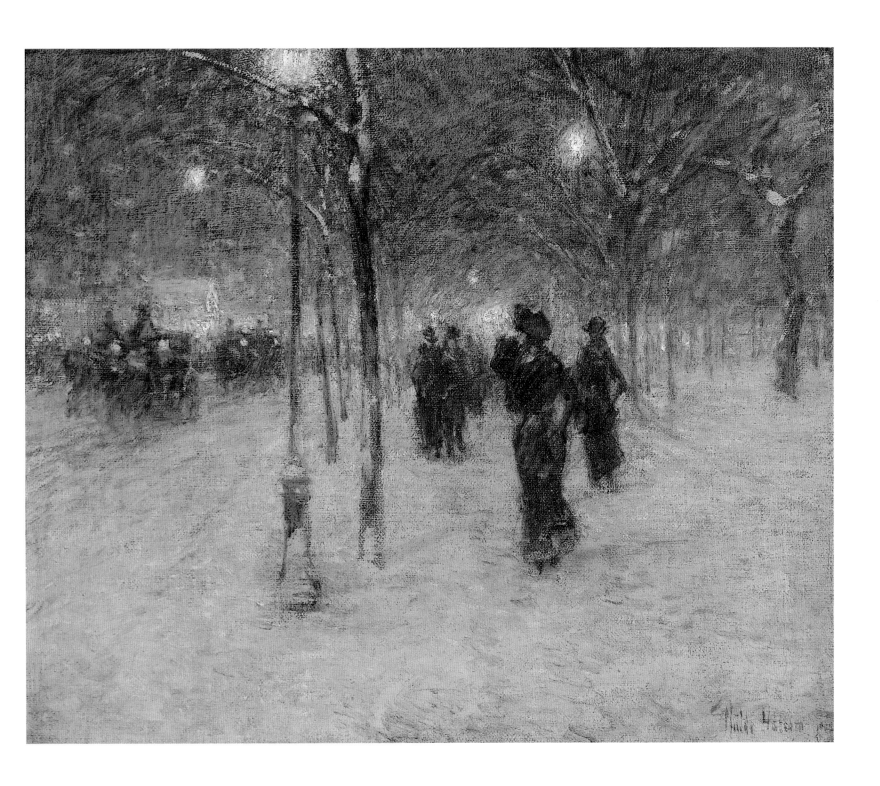

21
THE MESSENGER BOY, 1903
Oil on canvas
18¼ x 32¼ inches
Museum of Art, Rhode Island School of Design, Providence
Jesse H. Metcalf Fund

When the evening mist clothes the riverside with poetry, as with a veil, and the poor buildings lose themselves in the dim sky, and the tall chimneys become campanili, and the warehouses are palaces in the night, and the whole city hangs in the heavens, and fairy-land is before us—then the wayfarer hastens home;...nature, who for once, has sung in tune, sings her exquisite song to the artist alone.

James A. M. Whistler, *"Ten O'Clock": A Lecture* (Portland: Thomas Bird Mosher, 1910), pp. 13–14.

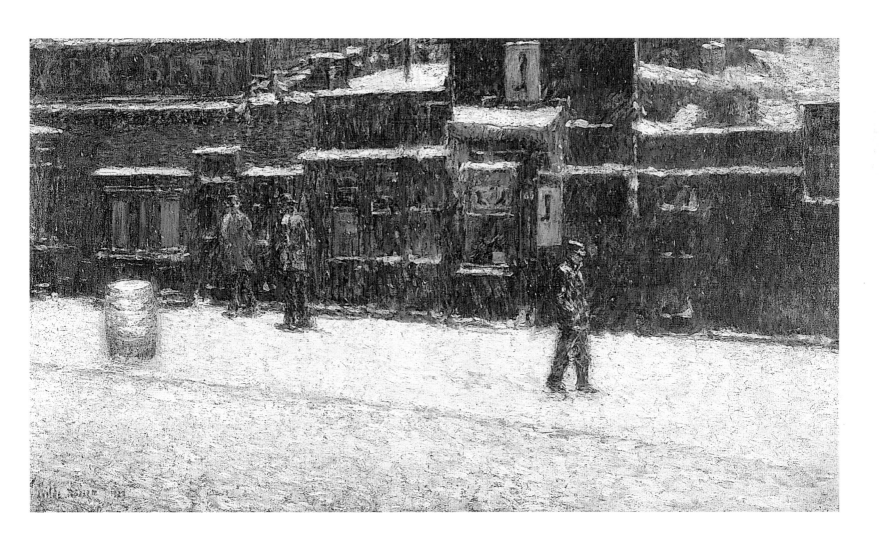

22
BROADWAY AND 42nd STREET, 1902
Oil on canvas
26 x 22 inches
The Metropolitan Museum of Art
Bequest of Miss Adelaide Milton de Groot
(1876 – 1967), 1967

What hurrying human tides, of day or night!

What passions, winnings, losses, ardors, swim thy waters!

What whirls of evil, bliss, and sorrow, stem thee!

What curious questioning glances—glints of love!

Leer, envy, scorn, contempt, hope, aspiration!

Thou portal—thou arena—thou of the myriad long-drawn lines
 and groups!

(Could but thy flagstones, curbs, facades, tell their
 inimitable tales;

Thy windows rich, and huge hotels—thy side-walks wide;)

Thou of the endless sliding, mincing, shuffling feet!

Thou, like the parti-colored world itself—like infinite,
 teeming mocking life!

Thou visor'd, vast, unspeakable show and lesson!

 Walt Whitman, "Broadway" in *Leaves of Grass*.

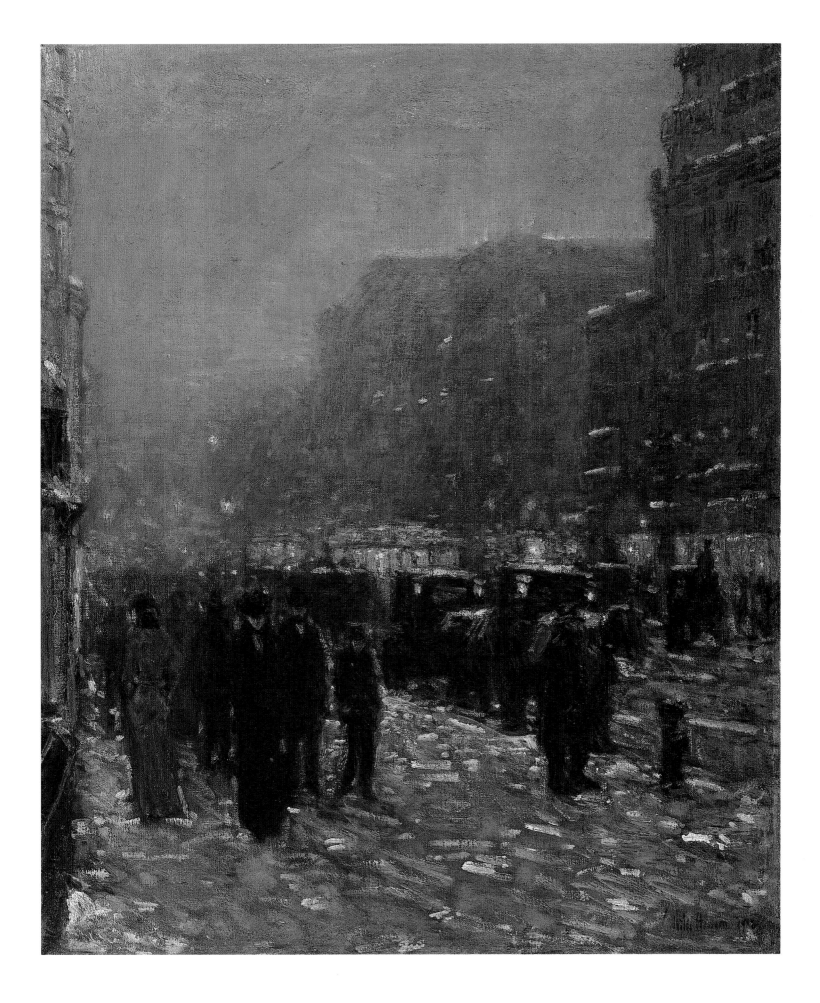

23
EARLY EVENING AFTER SNOWFALL, 1906
Oil on canvas
30 x 25 inches
Maier Museum of Art
Randolph-Macon Woman's College
Lynchburg, Virginia

Take [*Early Evening after Snowfall*] with its lone wayfarer, its cab waiting to go—whither?—its 'white wing' who has stayed his shovel and is looking off across the snow-bedded street through the blue-white haze which rests over all like some filmy, delicate scarf. The long line of sombre, mysterious houses, stretching away until they are lost in the mist, holds behind its impassive front a poignant suggestion of many lives, many hopes....For a space the ever-shifting ocean of metropolitan life is here calm....The city dreams....Every one of Mr. Hassam's New York pictures is pregnant with the same atmosphere, the same delicate mystery.

Louis Baury, "The Message of Manhattan," *The Bookman* 33
(August 1911): 601.

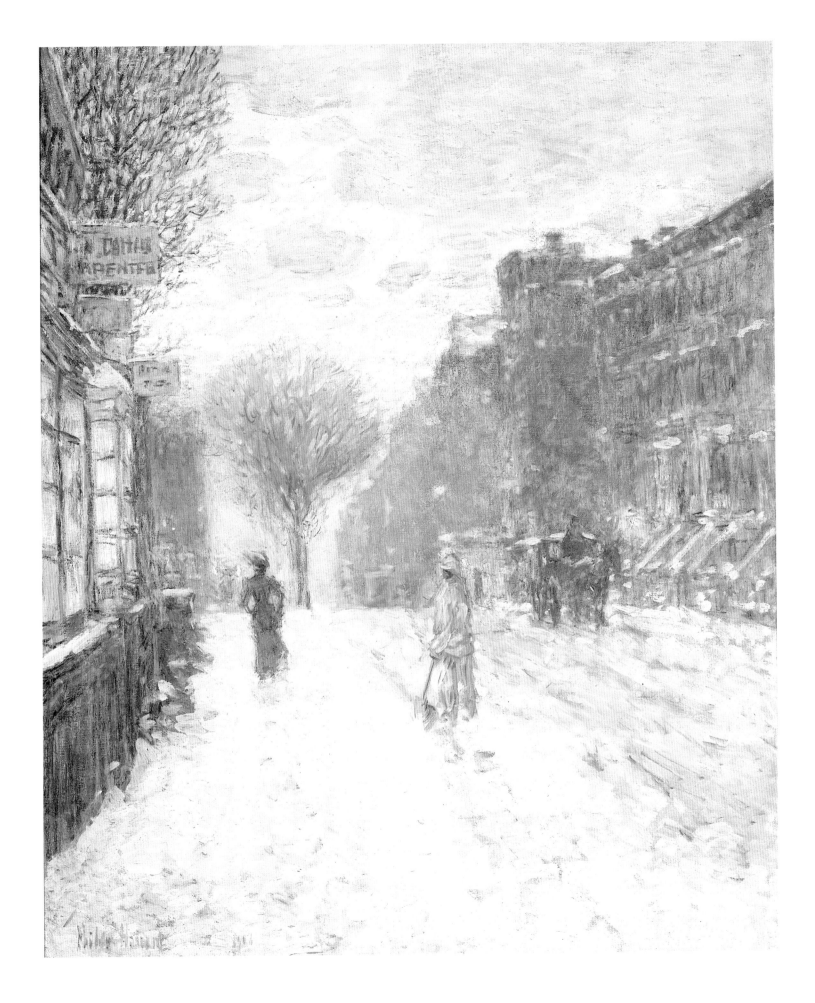

24
BROOKLYN BRIDGE IN WINTER, 1904
Oil on canvas
30 x 34 ¹/₁₆ inches
The Telfair Academy of Arts and Sciences, Savannah, Georgia
Museum purchase, 1917

We are a great industrial nation, but we are also an artistic one. Look at some of our great buildings, our bridges and viaducts. They in themselves are works of art. The trouble is that we have been called commercial so often that some have come to believe it.

S. J. Woolf, "Hassam Speaks Out for American Art," *New York Times Magazine,* October 14, 1934, p. 17.

"Brooklyn Bridge," a very recent painting, is a marvelously beautiful arrangement of opalescent tones. We look over a curious conglomeration of house-tops covered with snow, the great bridge looming beyond. The tonal qualities and the superb values in this painting show a most decided advance in Hassam's art.

A. E. Gallatin, "Childe Hassam: A Note," *Collector and Art Critic* 5 (January 1907): 104.

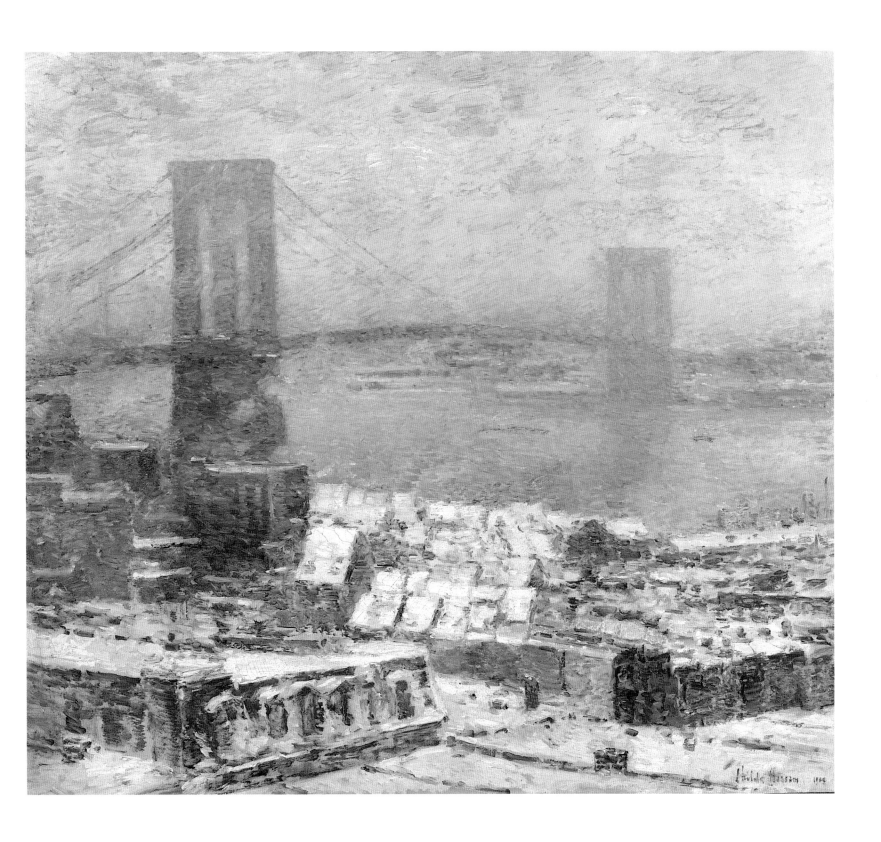

25
THE HOVEL AND THE SKYSCRAPER, 1904
Oil on canvas
34¾ x 31 inches
Collection of Mr. & Mrs. Meyer P. Potamkin

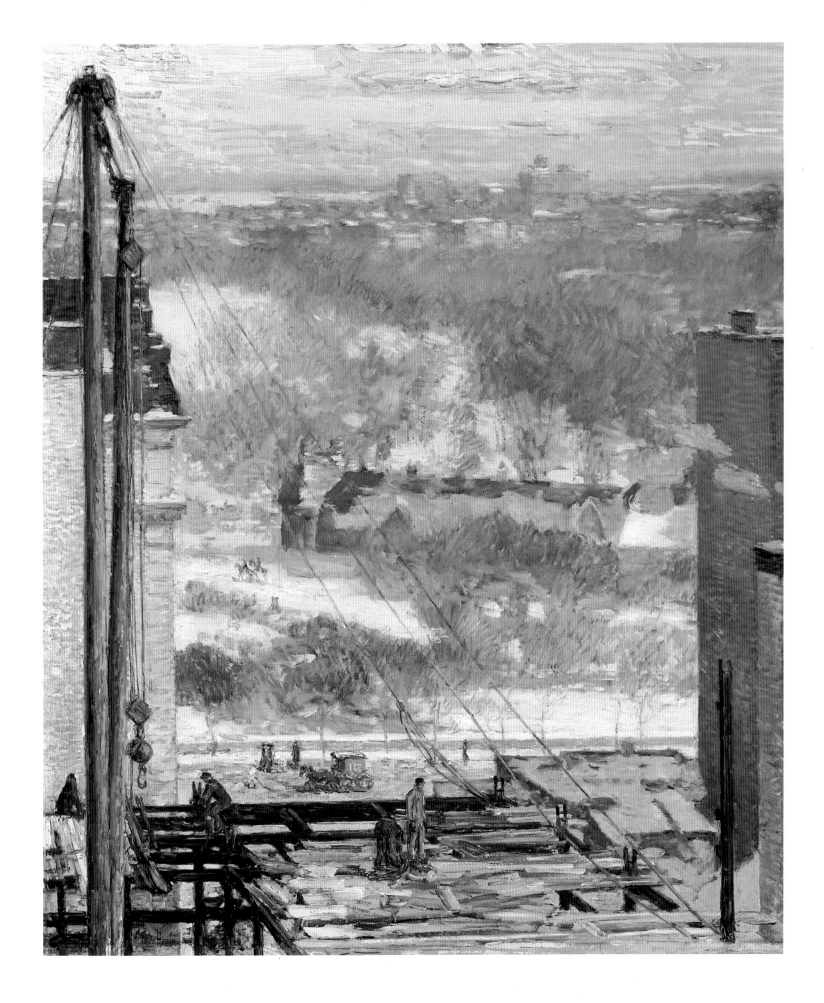

26
LOWER MANHATTAN [VIEW DOWN BROAD STREET], 1907
(formerly *BROAD AND WALL STREETS*)
Oil on canvas
30⅛ x 16 inches
Collection of Willard Straight Hall
Cornell University, Ithaca, New York
Gift of Mrs. Leonard K. Elmhirst, 94.70

Broad and Wall Streets holds all the close study and intimate familiarity of the painter of street scenes as he painted them many years ago, together with the more learned method of suggesting light and air characterizing his later paintings. The street is thronged with vehicles, the high buildings rise on either side like walls of a chasm, at the end of the vista we note the cool sunlight. It is all luminous and broad and delicately seen, a faithful and distinguished record of the business haunts of our romantic race.

Exhibition review, unidentified newspaper clipping, Childe Hassam
Papers, American Academy and Institute of Arts and Letters, New York
(on microfilm, Archives of American Art, roll NAA-1, fr. 539).

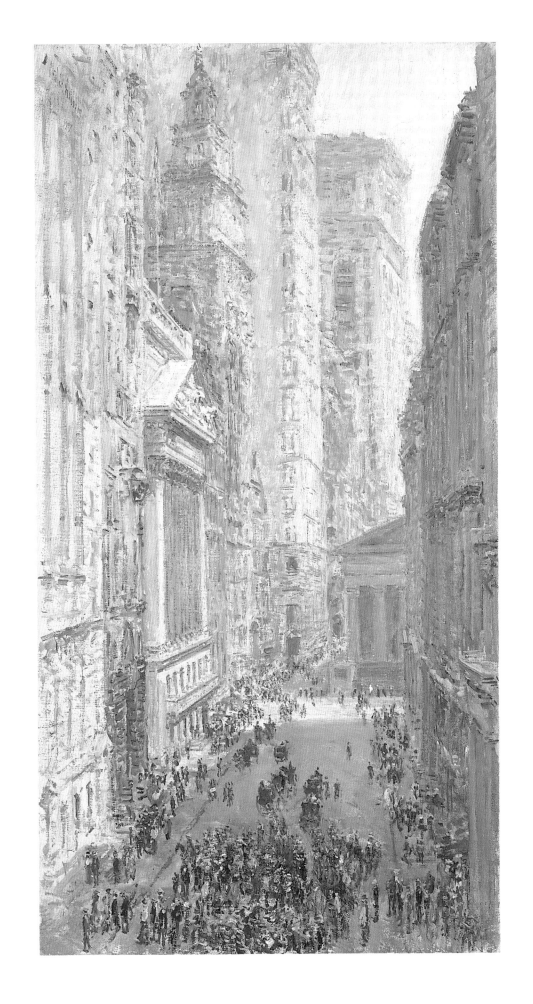

27
THE BREAKFAST ROOM, WINTER MORNING, 1911
Oil on canvas
25⅛ x 30⅛ inches
Worcester Art Museum
Worcester, Massachusetts
Museum purchase

Mr. Hassam's studio on West Fifty-seventh street overlooks the roofs
of many tall buildings, and the view of a wonderful zig-zag skyline seen
from his windows has been reproduced in one of his pictures.

"New York the Beauty City," *The Sun* [New York], February 23, 1913, p. 16.

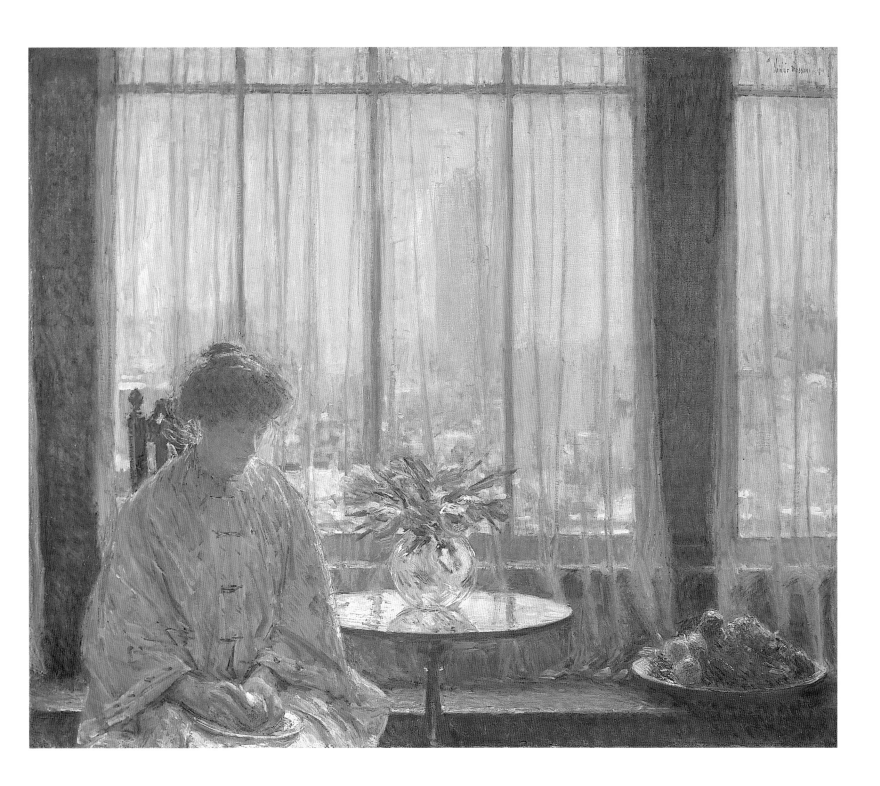

28
THE TABLE GARDEN, 1910
Oil on canvas
39½ x 29¾ inches
Mitchell Museum at Cedarhurst
Gift of John R. and Eleanor R. Mitchell

The carefully studied canvases in his famous New York Window
series show his mastery in rendering figures in "captive sunshine,"...
Such canvases, American in theme and treatment, have no "French
originals."

Adeline Adams, *Childe Hassam* (New York: American Academy of Arts
and Letters, 1938), p. 57.

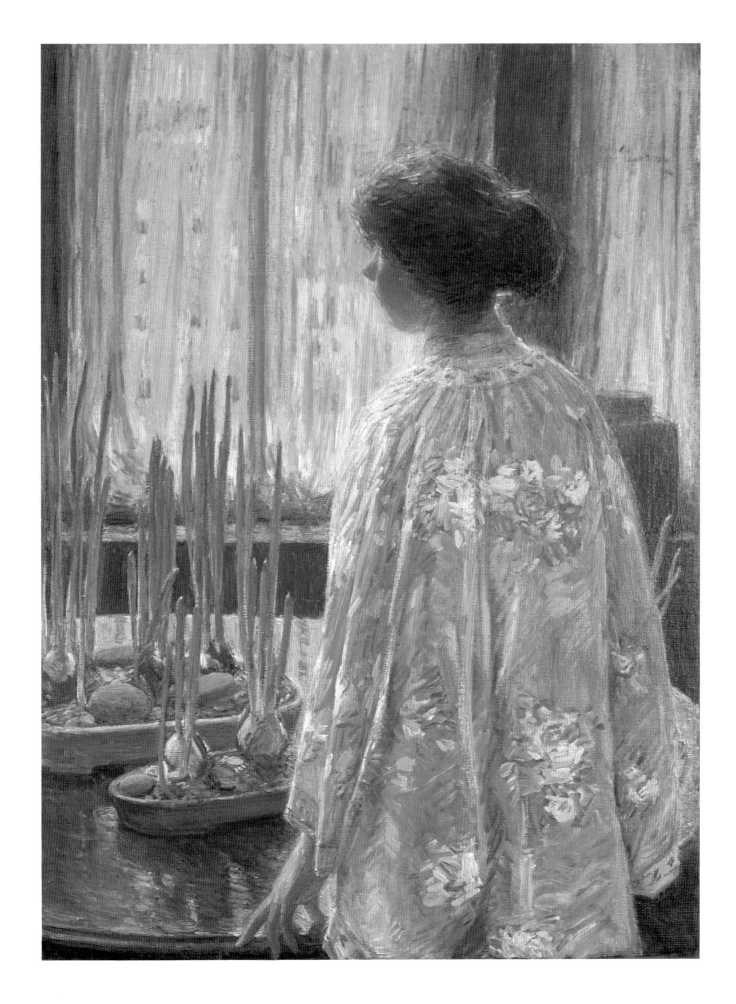

29
THE EAST WINDOW, 1913
Oil on canvas, 55¼ x 45¼ inches
Hirshhorn Museum and Sculpture Garden
Smithsonian Institution, Washington, D.C.
Gift of Joseph H. Hirshhorn, 1966
Photograph by Lee Stalsworth

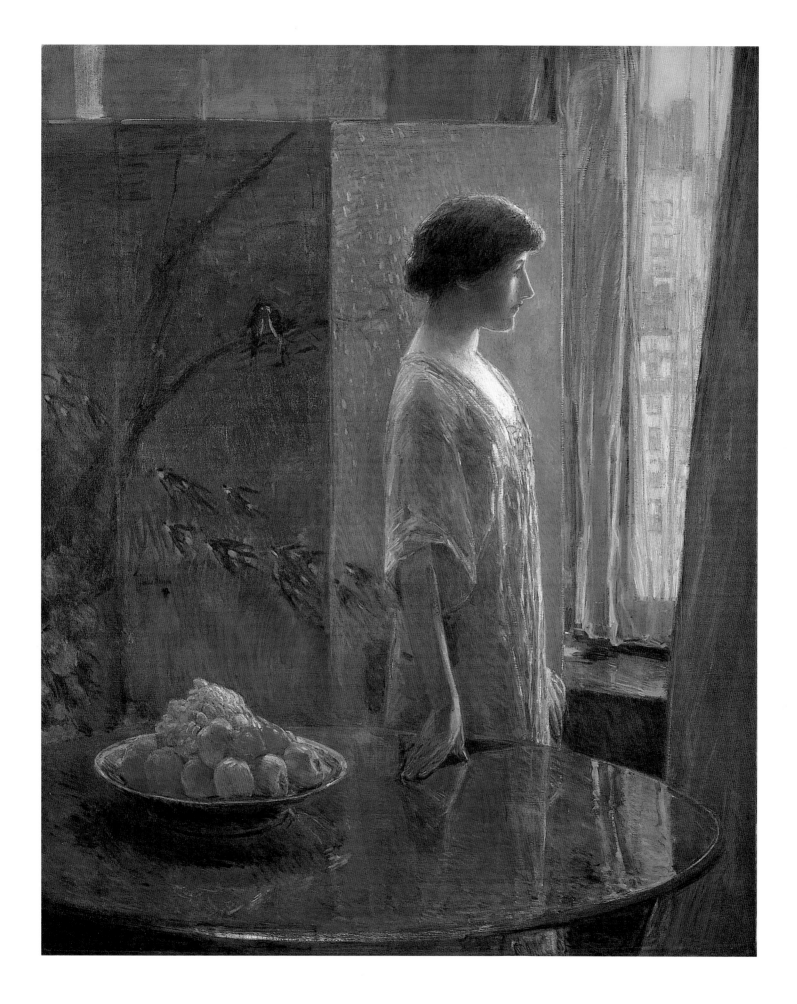

30
ALLIES DAY, MAY 1917, 1917
Oil on canvas
36½ x 30¼ inches
© National Gallery of Art, Washington
Gift of Ethelyn McKinney
In memory of her brother, Glenn Ford McKinney

[Fifth Avenue] he has done at various times, and over a long period.
...The most daring effort was to paint the Flags. No one had ever painted
flags before, so now when one thinks of flags one thinks of Hassam's
flag pictures. These pictures were not garish affairs, but were filled with
the poetry of patriotism. He made the Flags symbols of his heritage.
Only a Puritan could have painted flags as he did.

Ernest Haskell, "Introduction," in *Childe Hassam,* comp. by Nathaniel
Pousette-Dart (New York: Frederick A. Stokes, 1922), p. viii.

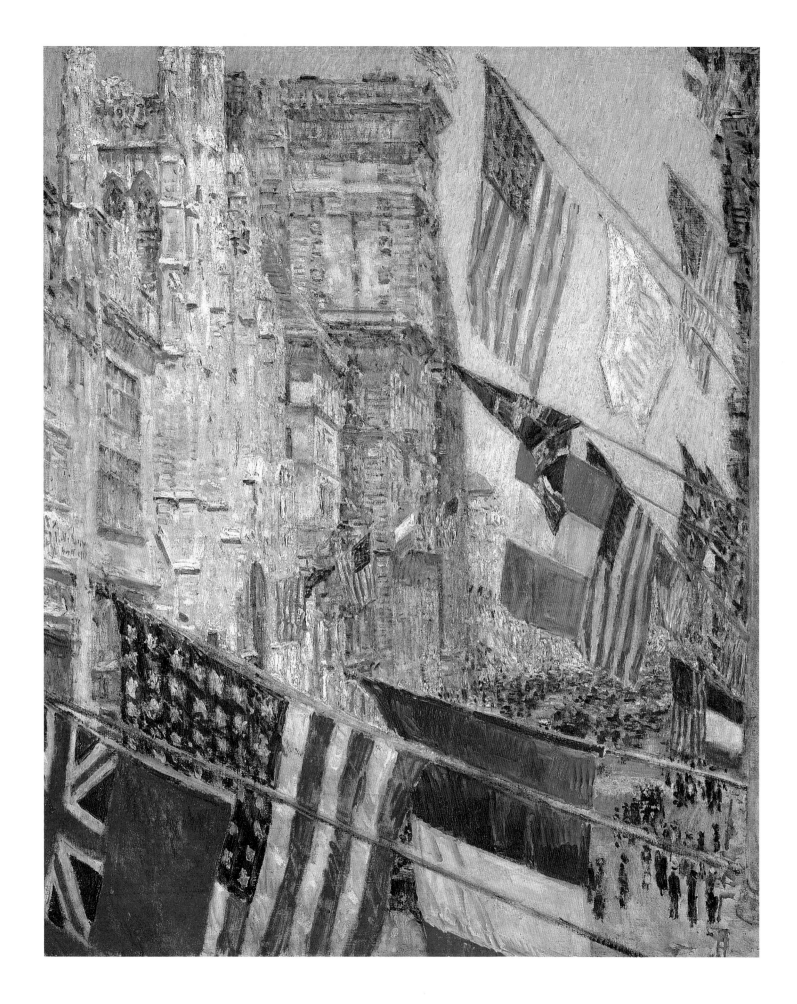

31
ALLIED FLAGS, APRIL 1917, 1917
Oil on canvas
30½ x 49 inches
Private collection
Photograph courtesy of Kennedy Galleries, Inc., New York

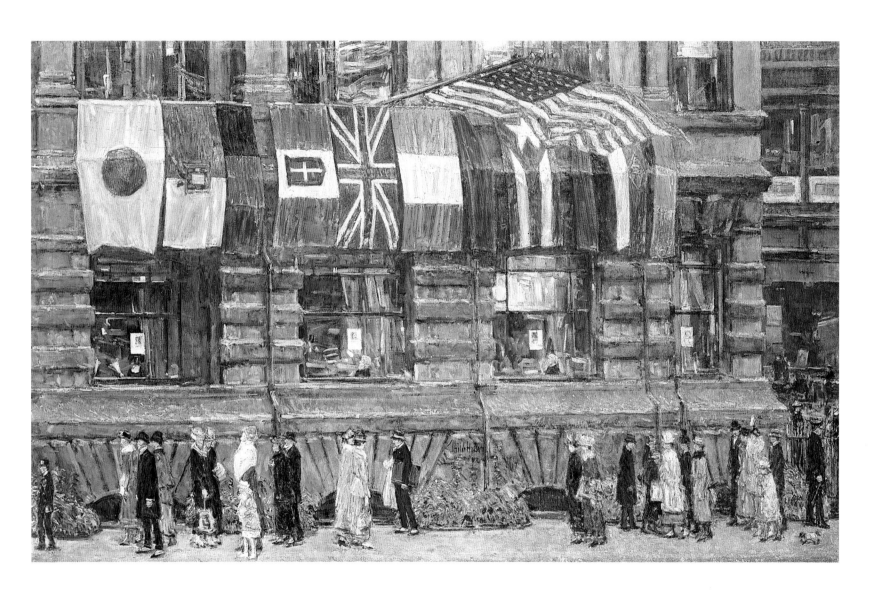

32
THE NEW YORK BOUQUET: WEST FORTY-SECOND STREET, 1917, 1917
Oil on canvas
35⅜ x 23⅜ inches
Collection of Mr. & Mrs. Hugh Halff, Jr.

The white sky-scraper of New York, that thoughtless people jeer at,
catches light as readily as a Moslem minaret; the solid "blocks" standing
shoulder to shoulder along the streets, the bunched group of high
buildings...make up walls more massive than those of Stamboul; and
if New York lacks the silvery domes of Constantinople, it is not without
its tall towers flying flags against the blue.

John C. Van Dyke, *The New New York* (New York: Macmillan, 1909), p. 5.

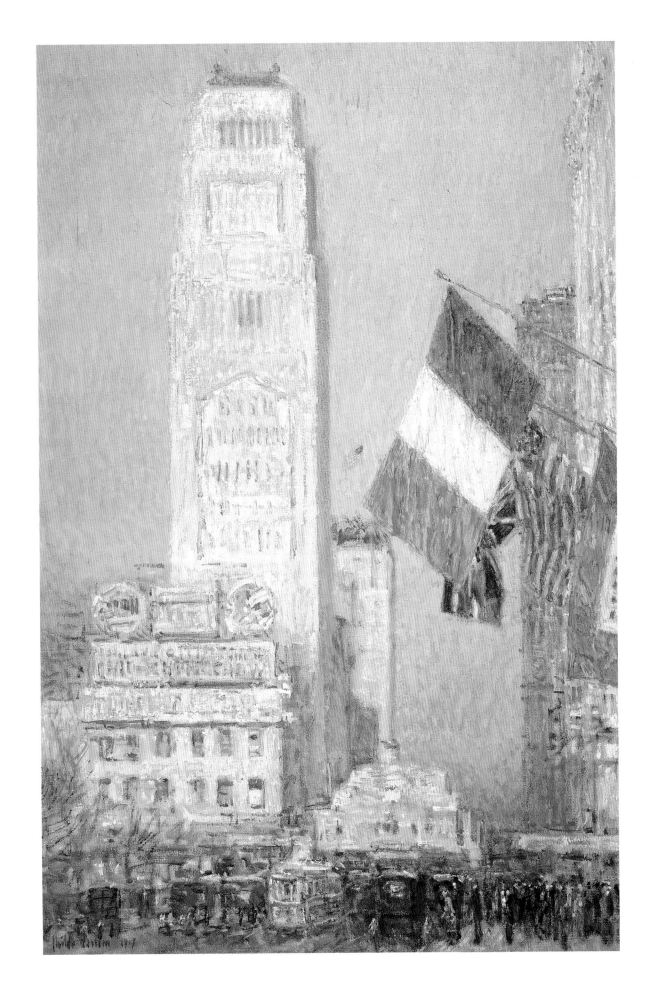

33
FLAGS ON FIFTY-SEVENTH STREET,
THE WINTER OF 1918, 1918
Oil on canvas
36⅛ x 24 inches
Courtesy of The New-York Historical Society

They [the flag pictures] have an extraordinary gusto and gayety, evoking just the temper in which you toss up your hat to get some of your joyousness into the air and out of your nerves. And this was the temper of be-flagged New York during the war. It will seem to future generations fed upon the literature of horrors and sacrifices almost incredible that they can be true records not only of the aspect but of the spirit of the city. Their spiritual truth, however, is what will keep them alive and important.

"Notes on Current Art," *New York Times,* June 1, 1919, sec. 3, p. 4.

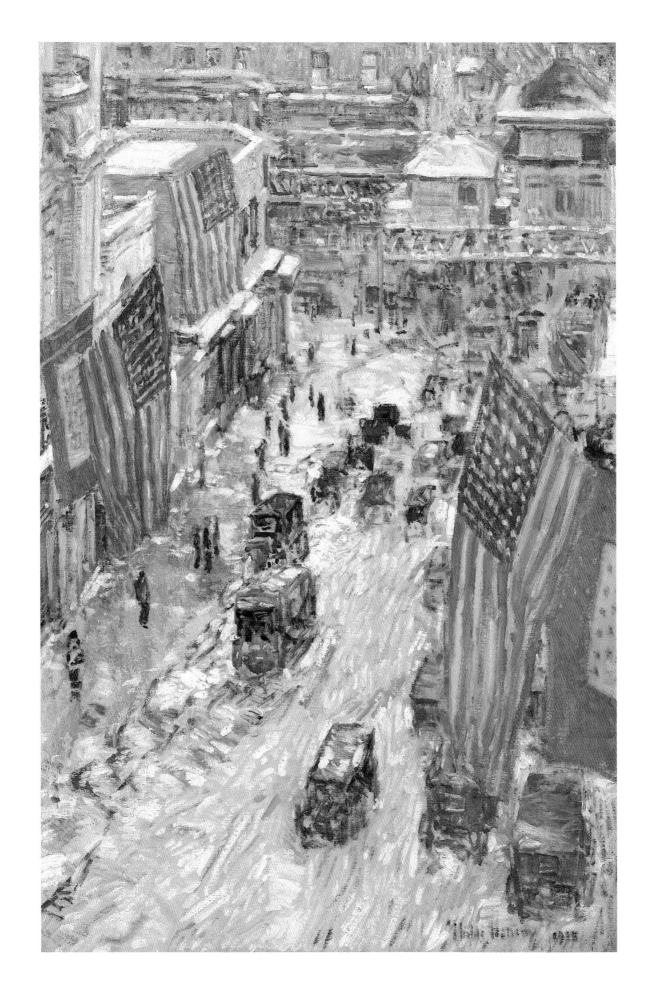

34
FIFTH AVENUE, 1919
Oil on canvas
23¼ x 19¼ inches
The Cleveland Museum of Art
Anonymous Gift, 52.539

To him [Hassam] Fifth Avenue is the most marvelous metropolitan street
in the whole world. One can never mistake this impressive Avenue for
any other street of any other city; there is nothing approaching it in
composition or in realization of man's sense of architectural beauty.
In his pictures, lives all that appeals to our patriotic and zealous love
of this street.

"Painting America: Childe Hassam's Way," *The Touchstone* 5 (July 1919): 272.

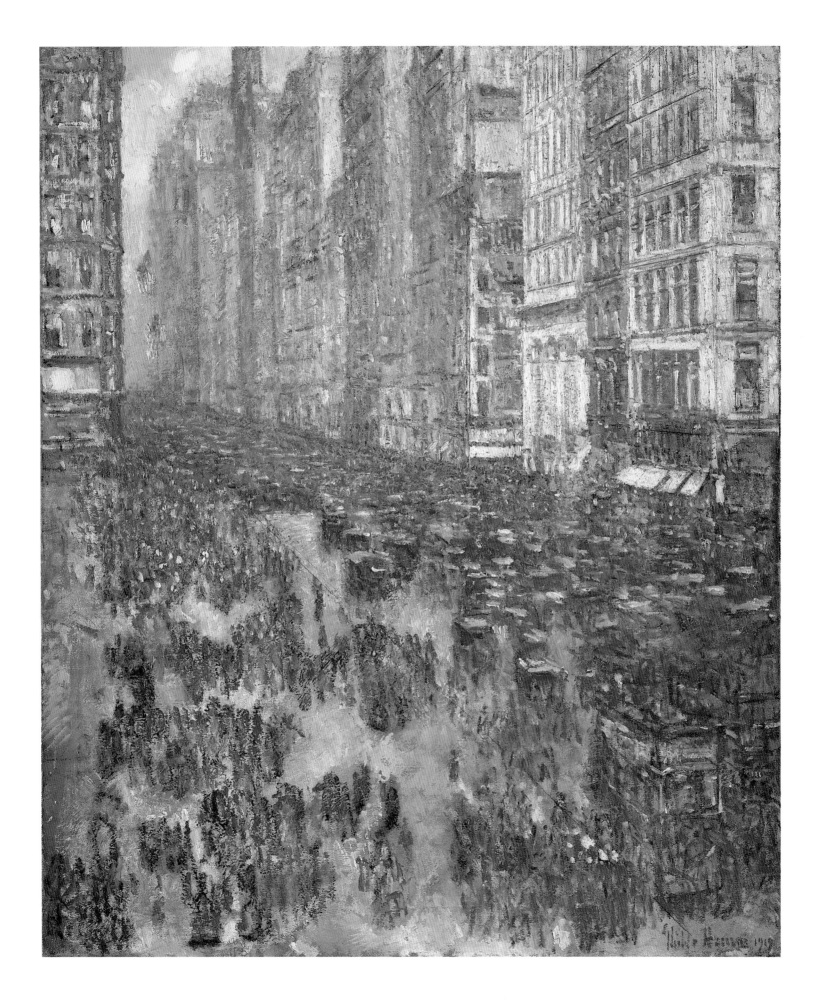

35

TANAGRA: THE BUILDERS, NEW YORK, 1918
Oil on canvas
58¾ x 58¾ inches
National Museum of American Art,
Smithsonian Institution, Washington, D.C.
Gift of John Gellatly
Photograph courtesy of Art Resources, New York

Tanagra—The blond Aryan girl holding a Tanagra figurine in her hand against the background of New York building—one in the process of construction and the Chinese lilys [sic] springing up from the bulbs is intended to typefy [sic] and symbolize groth [sic]—the groth of a great city hence the subtitle The Builders, New York.

Childe Hassam letter to John W. Beatty (director, Carnegie Institute),
March 8, 1920, in Carnegie Institute Papers, Archives of American Art.

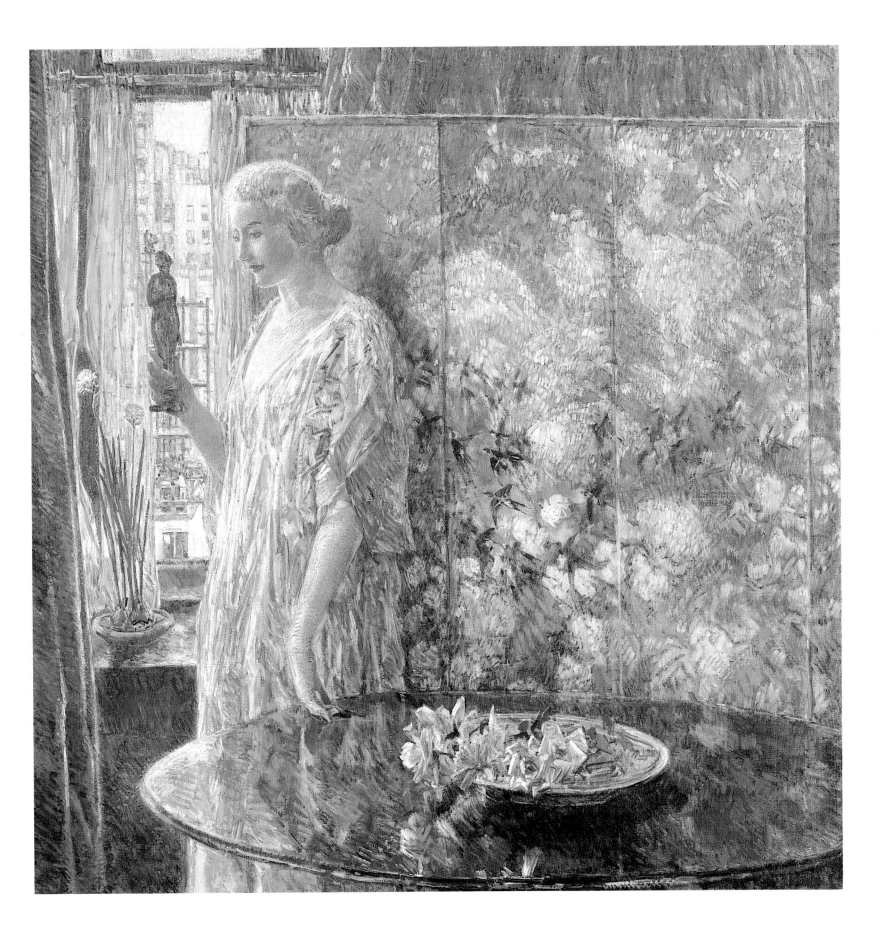

36
EASTER MORNING (PORTRAIT AT A NEW YORK WINDOW), 1921
Oil on canvas
36½ x 25½ inches
The Fine Arts Museums of San Francisco
Gift of Archer M. Huntington, 1936.9

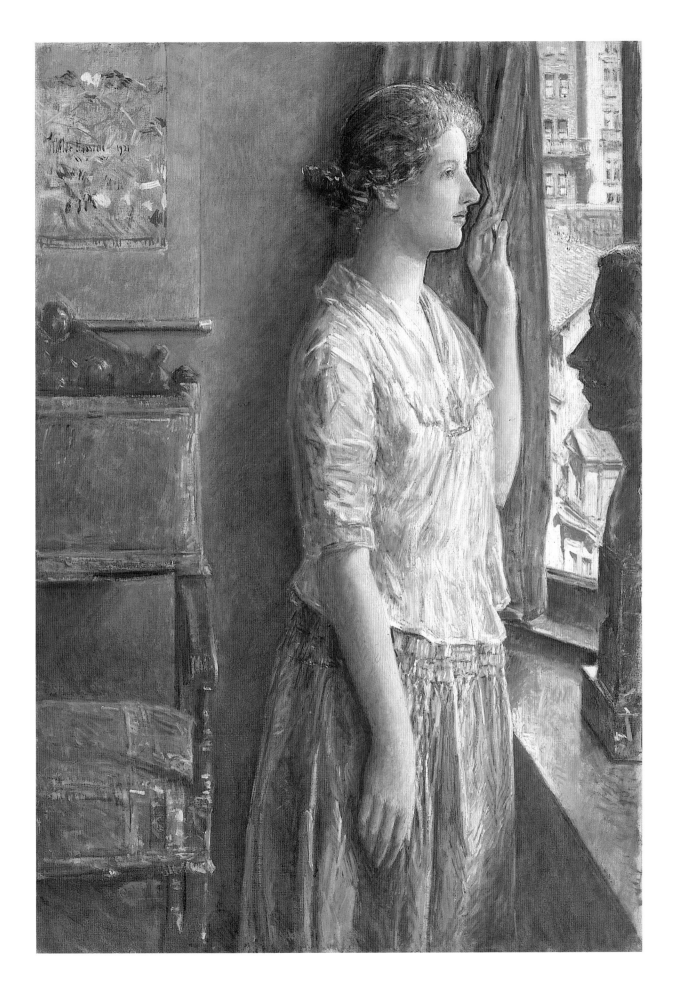

SELECTED BIBLIOGRAPHY

Hassam Archives

New York. American Academy and Institute of Arts and Letters. Childe Hassam Papers (microfilm, Archives of American Art).

Interviews with Hassam

Ives, A. E. "Talks with Artists: Mr. Childe Hassam on Painting Street Scenes." *Art Amateur* 27 (October 1892): 116–117.

"New York Beautiful." *Commercial Advertiser* [New York], January 15, 1898, p. 9.

"New York the Beauty City." *The Sun* [New York], February 23, 1913, p. 16.

New York. New-York Historical Society. De Witt McClellan Lockman Papers. Lockman interview with Childe Hassam, 1927 (microfilm, Archives of American Art).

Books by Hassam

Three Cities. New York: R. H. Russell, 1899.

Books about American Impressionism with Significant Discussion of Hassam

Boyle, Richard A. *American Impressionism.* Boston: New York Graphic Society, 1974.

Gerdts, William H. *American Impressionism.* Exhibition catalogue. Seattle: Henry Art Gallery, University of Washington, 1980.

────. *American Impressionism.* New York: Abbeville, 1984.

Hiesinger, Ulrich W. *Impressionism in America: The Ten American Painters.* New York and Munich: Jordan-Volpe Gallery with Prestel-Verlag, 1991.

Books and Articles about Hassam

Howe, William Henry, and Torrey, George. "Childe Hassam." *Art Interchange* 34 (May 1895): 133.

Morton, Frederick W. "Childe Hassam, Impressionist." *Brush and Pencil* 8 (June 1901): 141–150.

Hartmann, Sadakichi. "Studio-Talk." *International Studio* 29 (September 1906): 267–270.

Meyer, Annie Nathan. "A City Picture: Mr. Hassam's Latest Painting of New York." *Art and Progress* 2 (March 1911): 137–139.

"Painting America: Childe Hassam's Way." *Touchstone* 5 (July 1919): 272–280.

Clark, Eliot. "Childe Hassam." *Art in America* 8 (June 1920): 172–180.

Pousette-Dart, Nathaniel, comp. *Childe Hassam.* Distinguished American Artists. Introduction by Ernest Haskell. New York: Frederick A. Stokes, 1922.

Price, F. Newlin. "Childe Hassam—Puritan." *International Studio* 77 (April 1923): 3–7.

Catalogue of the Etchings and Dry-Points of Childe Hassam, N.A. Introduction by Royal Cortissoz. New York: Scribner's, 1925.

Kleeman Galleries. *The Lithographic Work of Childe Hassam.* Foreword by C. Henry Kleeman. New York, 1934.

Adams, Adeline. *Childe Hassam.* New York: American Academy of Arts and Letters, 1938.

Griffith, Fuller. *The Lithographs of Childe Hassam: A Catalog.* United States National Museum, *Bulletin* 232. Washington, D. C.: Smithsonian Institution, 1962.

Corcoran Gallery of Art. *Childe Hassam: A Retrospective Exhibition.* Introduction by E. Buckley. Washington, D. C., 1965.

University of Arizona Museum of Art. *Childe Hassam, 1859–1935.* Exhibition catalogue. Essay by William E. Steadman. Tucson, 1972.

Hoopes, Donelson F. *Childe Hassam.* New York: Watson-Guptill, 1979.

Bienenstock, Jennifer A. "Childe Hassam's Early Boston Cityscapes." *Arts Magazine* 55 (November 1980): 168–171.

Guild Hall Museum. *Childe Hassam, 1859–1935.* Exhibition catalogue. Essays by Stuart Feld and Judith Wolfe. East Hampton, New York, 1981.

Fort, Ilene Susan. *The Flag Paintings of Childe Hassam.* Exhibition catalogue. Los Angeles and New York: Los Angeles County Museum of Art in association with Harry N. Abrams, 1988.

Burnside, Kathleen. "New York in the 1890s: The Cityscapes of Childe Hassam." In *Sotheby's Art at Auction, 1988–89,* pp. 166–171. New York: Sotheby's, 1989.

Curry, David Park. *Childe Hassam: An Island Revisited.* Exhibition catalogue. Denver and New York: Denver Art Museum in association with W. W. Norton & Co., 1990.